Beyond the Plane

The Relief Paintings of Judith Rothschild

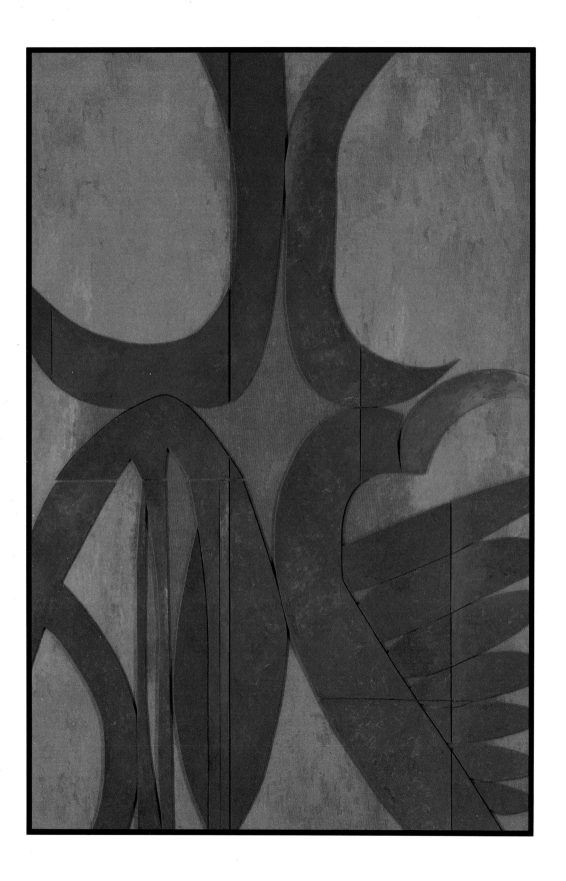

Beyond the Plane

The Relief Paintings of Judith Rothschild

by Richard H. Axsom

Hudson Hills Press, New York

First Edition
Text © 1992 by Richard H. Axsom
Illustrations © 1992 by Judith Rothschild

Published in the United States by Hudson Hills Press, Inc., Suite 1308, 230 Fifth Avenue,
New York, NY 10001-7704.

Distributed in the United States, its territories and possessions, Canada, Mexico, and Central and
South America by National Book Network, Inc.
Distributed in the United Kingdom and Eire by Shaunagh Heneage Distribution.
Distributed in Japan by Yohan (Western Publications Distribution Agency).

Editor and Publisher: Paul Anbinder

Color Photography: Christopher Burke, Quesada/Burke, N.Y.

Copy Editor: Judy Spear

Proofreader: Lydia Edwards

Indexer: Gisela S. Knight

Designer: Susan Evans

Composition: U.S. Lithograph, typographers

Manufactured in Japan by Toppan Printing Company

Library of Congress Cataloguing-in-Publication Data

Rothschild, Judith
 Beyond the plane : the relief paintings of Judith Rothschild / Richard H. Axsom.
 p. cm.
 Catalogue of an exhibition held at Tretyakov Gallery, Moscow, in 1991.
 Includes index.
 1. Rothschild, Judith—Exhibitions. 2. Relief (Art)—United States—Exhibitions. I. Axsom,
Richard H., 1943– . II. Title.
 N6537.R645A4 1992
 759.13—dc20 92-12136
 CIP

Frontispiece: **The Gothic XI,** 1991

ISBN: 1-55595-077-9 (alk. paper)

Artist's Note

Judith Rothschild, March 1992

How serious and dangerous it is curiously to examine the things which are beyond one's understanding, and to believe in new things . . . and even to invent new and unusual things, for demons have a way of introducing themselves into such-like curiosities.

Addressed to Joan of Arc, 1430
Proces de condamnation, Vol I, page 390.

Language is like a cracked pot on which we beat out a music for bears to dance to, when all the time we want to write music that will bring tears to the stars.

Gustave Flaubert
(Trans. by Francis Steegmuller)

Along the way we all need some good luck. I count myself tremendously fortunate to have known Antonina Gmurzynska, whose vision and courage and support of artists and of the art she loved places her alongside the great dealers of the recent past. Like Vollard and Kahnweiler, Antonina had an impeccable eye, and a wonderful passion. This volume is dedicated to her memory.

Antonina Gmurzynska
(1926–1986)

Contents

Foreword

The Tretyakov Gallery devoted an extensive exhibition to the American Judith Rothschild for reasons that relate to the Russian tradition: the artist's work is seen within a continuum that developed partly in Russia in the early 1900s. In the Bauhaus and the Dutch de Stijl group, there arose a thoroughly new awareness of art, very much alive to this day, that calls for ever-new solutions and variations on an almost inexhaustible theme. The artists of the twenties worked on and with space that was no longer restricted to depiction of the world through illusionism. Instead they sought to express reality by what they called "the concrete." In Russia examples of such artists were Malevich, Tatlin, Puni, and Rodchenko; in Germany, the inventors of Constructivism and a few Dadaists; in the Netherlands, principally Mondrian and van Doesburg; and in France, the Cubists led by Picasso and Braque. That the theme has persisted in the production of later artists can be seen in the work of Judith Rothschild. Her relief paintings, generated over two decades, are, on the one hand, a tribute to a fascinating European heritage and, on the other, a view of concrete space that is essentially American. In appraising Judith Rothschild's works, I fully support the impressions of Sir Roland Penrose: "These paintings give us a sense of joy, well-being and happiness by showing us new visions. One could say much more, but it is better to succumb to them, and let them fill us with their visible music." (See "Selected Solo Exhibitions," 1981.)

I would like to thank those responsible for helping with the organization of "Beyond the Plane," most notably the Galerie Gmurzynska in Cologne, without whose constant commitment this project would not have been possible. I express my particular thanks to Judith Rothschild, who was always ready to assist in a most cooperative way. The Tretyakov Gallery takes great pleasure in presenting the works of this wonderful artist.

(statement on the occasion of the exhibition "Beyond the Plane: The Relief Paintings of Judith Rothschild," September–October 1991)

Ivanovich Korolev
Director, The State Tretyakov Gallery,
Moscow

Preface

William J. Hennessey
Director, University of Michigan Museum
of Art

Judith Rothschild's work is remarkable on a number of counts. For nearly fifty years she has been making paintings, drawings, and collages of rare quality and interest. Despite her great productivity, Rothschild's work shows a rare consistency of vision. In an era when artistic fashions and preoccupations seem to change weekly, it is refreshing to encounter an artist who knows so deeply and clearly who she is and in what she believes.

This book provides Rothschild's many admirers with a welcome chance to study in depth a small section of her large and varied oeuvre. The result is an almost musical experience of variations on a series of themes pursued within the great tradition of twentieth-century modernism. Inspired by her European and American teachers and friends (including Hans Hofmann, Marcel Duchamp, Piet Mondrian, Sonia Delaunay, Robert Motherwell, Milton Avery, and many others), Rothschild has developed a refined, elegant, and eloquent style all her own.

Most of Rothschild's art is abstract, but hers is an abstraction that reveals careful observation of and deep love for the physical world around us—the presence of the human body, or of stones or flowers—as the solid foundation underlying the forms. Her work never loses touch with the heritage of Mediterranean civilization with its inherent respect for the tangible. In the broadest sense she explores the fundamental and perennially fascinating subject of humanity's relationship to the surrounding landscape.

World events have added a dramatic dimension to the present project, initiated by the Soviet Ministry of Culture on behalf of the Tretyakov Gallery in Moscow: it was there, during the last days of the former regime, that Rothschild was given a solo exhibition in that museum's principal gallery—the first American artist to be so honored in a space usually reserved for shows of Russian masters such as Liubov Popova, Kazimir Malevich, and Wassily Kandinsky. We are pleased to present this sampling of Judith Rothschild's work shared so recently with our colleagues in Moscow.

Acknowledgments

Of the many achievements of twentieth-century art, none has been more critical than abstraction. Its disavowal of illusionism has marked the most radical expansion of the West's visual traditions since the Renaissance. And although abstraction has been woven into the century's historical fabric with other directions, abstraction did dominate modern art at midcentury when modernism itself seemed defined by it. Remarkably diverse in expression, abstraction has nonetheless been constant in its aim—often declared by its artists and conferred upon it by its commentators—to go beyond the specific and give image to the universal through the evocative power of surface, shape, and color.

What drew me to Judith Rothschild's relief paintings was how richly they were situated within the traditions of abstraction and how they spoke of the century as a whole rather than representing a specific movement. Early modernist in its forms and collage sensibility yet later modernist in materials and a willingness to break forward of the tangible picture plane, Rothschild's art embodies a subtle eclecticism that elaborates upon tradition while maintaining a distinctive and original voice. The visceral appeal of Rothschild's color and raised surfaces and the sensual vivacity of her forms give eloquent evidence for abstraction, resting its arguments not on illusion or concept but upon physical immediacy. With a poignant, sometimes tough lyricism that is always life affirmative, Rothschild's relief paintings explore the variety of beauty as expressed through the transcendental forms of abstraction.

As curator of the Rothschild exhibition and project coordinator of its American venue, I am deeply indebted to a number of people. First I should like to thank Bill Alonso, Judith Rothschild's curatorial assistant, for a professionalism that facilitated an examination of documentation and the artist's oeuvre. The book itself would have not been possible without Paul Anbinder, president of Hudson Hills Press, who stepped forward to act upon his own enthusiasm for Rothschild's work. I am profoundly grateful to him for publishing my manuscript and for providing me with a most able editor, Judy Spear. I should also like to acknowledge Bill Hennessey, Director of the University of Michigan Museum of Art, for accepting the Rothschild exhibition and providing the necessary second anchor for an American-Russian axis that was secured on the other end by the Tretyakov Gallery in Moscow.

For their supportive endorsements of Rothschild's art and for their steadfastness as friends, I wish personally to thank Dale R. Namio and to remember Deborah C. Brown by dedicating this book to her.

Finally, I would like to thank Judith Rothschild for the gift her art has been for me and for for her generous participation in the project. She evidenced a much-appreciated concern that all be done with the greatest attention to historical and aesthetic detail. I thank her for her time and for all the provocative and stimulating ideas that surfaced in our many amiable conversations. Judith Rothschild has my highest esteem for her intelligence as an artist and for the inspirational high seriousness with which she undertakes the making of art.

Richard H. Axsom

Beyond the Plane

The Relief Paintings of Judith Rothschild

Judith Rothschild came of age as a modern artist in the 1940s. During the Depression years of the previous decade, American painting had become isolated from modern art and defined by the conservative styles and regional subject matter of the American Scene and social realist artists. Modernism in the United States was considered European. It was not until the late 1930s that there was any strong awareness of what was going on in Europe or where modernism might be leading. But even this understanding was limited to a few artists and to a very few centers of art. The most important group to maintain an allegiance with the European avant-garde was in New York and was formally identified in 1937 as the American Abstract Artists. On the eve of World War II progressiveness for these New York painters was situated around Pablo Picasso and the School of Paris legacy of Cubism and Surrealism. At the same time Constructivism as it had developed in Holland, Germany, and the Soviet Union was just beginning to be known.

As a young artist who early preferred the European avant-garde to the more popular American native styles, Rothschild was lucky to have grown up in New York City. Commercial art galleries were relatively few in number at the time, but there were several that loyally showed European modernist art. At the newly opened Museum of Modern Art on West 53d Street, a prestigious collection of early-twentieth-century art was being assembled during the 1930s, and in it were masterpieces from the Impressionist and Post-Impressionist periods. In 1936 the museums's first director, Alfred H. Barr, Jr., organized the landmark exhibition "Cubism and Abstract Art." The Museum of Non-Objective Art, later the Solomon R. Guggenheim Museum, was housed in temporary quarters but always showed a generous trove of paintings by Wassily Kandinsky. At An American Place, Alfred Stieglitz's gallery, there was a constant display of work by John Marin, Marsden Hartley, and Georgia O'Keeffe, as well as a sensed proximity to the most prominent European artists and writers to whom they related. Rothschild had access to these sources of modernism in New York and was inspired by them.

The German expatriate artist Hans Hofmann, who had been teaching in the United States on the West Coast in the early 1930s, opened his famous art schools in New York City and Provincetown, Massachusetts. In 1944, after Rothschild finished college, she enrolled with Hofmann in New York. She also worked during the later 1940s at Stanley William Hayter's influential graphic workshop, Atelier 17, which had been transferred from Paris to New York in 1940. She served as Hayter's studio monitor to earn tuition money. At the same time she began translating into English some of the writings of Jean Arp, Piet

Mondrian, Max Ernst, Georges Braque, Pablo Picasso, Joan Miró, and others, circulating the translations among her artist friends.

The art world in New York was small in those days. Within it the circle of avant-garde artists who had fled Europe before and during World War II was even smaller. Inevitably Rothschild began to come in contact with the artists whose work she had been admiring. Joan Miró came to the city and worked briefly at Hayter's. Jacques Lipchitz and occasionally Alexander Calder were there. Jean Hélion and Fernand Léger lived a few blocks south of Rothschild's studio on Twelfth Street, as did the sculptor Ossip Zadkine.

Mondrian had come to New York in 1940 and had joined the American Abstract Artists group. With Mondrian as a member, the AAA was the most significant beachhead for abstraction in a United States that was still quite content to consider such an aesthetic utterly irrelevant. In 1946, when Rothschild was voted into the AAA, membership was limited to a select few and followed careful evaluation and debate by members. Because it was bestowed by colleagues, it was an honor especially valued.

Rothschild's first solo exhibition in New York in 1945 at the Jane Street Gallery—a presentation of paintings and collages—earned her a respected place in the art community. It was well attended and well reviewed. John Bernard Myers was impressed with the work and wrote about it in the Surrealist magazine *Triple V.* W. H. Auden and Paul Goodman came, as did Hans Hofmann and Marcel Duchamp, the latter singling out *Mechanical Personnages I* (fig. 2; see also fig. 3) as his own favorite. Duchamp, seeing an intrinsic affinity between the collages of Kurl Schwitters and those on the walls of the Jane Street Gallery (see fig. 4), was to introduce Rothschild to the work of that artist.

Rothschild's paintings of the 1940s, reflecting varying amalgamations of Cubist, Surrealist, and abstract idioms, were classically early modernist in terms of compositional and formal ideals (see figs.1, 3 and 5). But her art was not abstract in the conceptual terms that for many artists had come to define abstraction during the previous decade, nor was it genuinely Surrealist.

In the 1930s, under the influence of Russian Constructivism and the teachings at the Bauhaus in Germany, geometric abstraction had become less referential and lacked much of the metaphysical content formally ascribed to it. Theo van Doesburg had in fact coined the word *concrete* to refer to the prevailing geometric tradition of international abstraction, an orientation producing works of art that owed nothing to nature for their formal inspiration. Rothschild, like Mondrian and Arp before her as well as one wing of the American Abstract Artists, found this attitude uncongenial, forgoing as it did any profound response to nature. Drawn to allusive abstract form throughout her oeuvre, she has always recognized the a priori importance of nature to her work. In response to the query posed to many artists in Europe about the role of nonobjective art arrived at from a purely intellectual base, Miró had stated: "Do not ask me to share the empty room of the non-objective artists." Rothschild wholeheartedly agreed.

Rothschild's attraction to nature would, in fact, lead in the early work and in the relief paintings to the inclusion of protean, biomorphic forms that suggest affinities with Surrealist abstraction, particularly as epitomized by the shapes of Arp and Miró. If it is the case, however, that her shapes are sometimes so referential and freely drawn as to link her work with poetic Surrealism, the relationship needs qualification. Rothschild's respect

for automatism as a metaphor for intuition precluded the extreme positions of Surrealists who championed actual spontaneous creation.

With these qualifications made, European influences still helped shape Rothschild's first exhibited work, and their resonance is felt in the entire body of her later work as well. Her very willingness to respect the European tradition, if only as a springboard, runs counter to an American penchant for casting off the perceived shackles of history to gain authenticity.

Yet Rothschild's work as a whole also embodies an evident American spirit: an expansive sense of space and light aligns it with American painting from the landscapes of the Hudson River School to this century's Color Field abstraction. In their receptive embrace of nature, as stated by energetic forms, Rothschild's paintings assert an American identity and join a diverse American tradition of lyrical abstraction exemplified by Milton Avery and Mark Rothko.

Despite this generic Americanness, Rothschild's paintings, which were not completely synchronized with European developments of the moment, have never been in exact step with a chronological progression of contemporary American art. American painting dominated international art in the postwar era with Abstract Expressionism in the late 1940s and 1950s and with Minimalist abstraction during the 1960s. Antithetical in character, these two movements fostered their own programs, neither oriented to the direction Rothschild's art was taking. Abstract Expressionism's avowed dedication, particularly that of the action painters, was to honor unfettered impulse. Minimalism's hard-edge pursuit led to a formalist art without reference or metaphor. Rothschild, on the other hand, was committed to finding within the language of abstraction subjects that would be evocative (without being literal or autobiographical) and a means of distancing the evidence of the artist's own presence from the work. Clearly these combined aims were against the American grain of the moment.

During the 1950s Rothschild implemented her ideals with figurative, still-life, and landscape motifs that were resolved in elaborations of the Cubist-inspired abstractions of the previous decade (see figs. 6–9). Sustaining aspects of these interests into the 1960s, and refracting them through explorations of color theories (such as those of Wilhelm Ostwald), the artist produced spare yet color-dense oils whose compositional and thematic format was the abutment of open expanses of sky and earth as they meet along an uninterrupted horizon line (figs. 10–12). Over these two decades Rothschild worked outside New York City. She would move residence over twenty-five times to locations including the Big Sur in California, upstate New York, Cape Cod, and France.

When Rothschild returned to New York in the early 1970s, after a twenty-three-year absence, the postwar art scene was in the process of a major shift. Her reentry into New York coincided with a Postmodernist cultivation of pluralist attitudes that challenged the strictures of Minimalist form (or the notion of a single mainstream style) and the authority of American art as the sole progressive model of modernism. Contemporary art was now being shaped equally by European artists, as demonstrated by German and Italian Neoexpressionists who were receiving critical acclaim by the late 1970s. Also by this time a new generation of American painters had begun to expand on the nonobjective modes of Minimalism and to embrace referential form and content. Old shibboleths were

questioned, such as the absolute sanctity of the picture plane and the divorce of painting from all but formalist considerations. A new figurative painting and an emerging Neoabstraction, marked by appropriations of earlier-century styles, gave image to personalized reflections variously on self, society, and nature.

It was at the beginning of this decade of change that Rothschild began to explore the possibilities of the relief medium. Since Impressionism there has been a pressuring forward of the picture plane, first in plays between illusionism and physical surface and later, after Paul Cézanne and Cubism, in the painted surface as a reality in its own right, devoid of any appeals to illusionistic form. During the twentieth century, with Picasso's Cubist relief constructions of 1912–14, this concern has provoked a fundamental redefinition of sculpture. It has resulted in hybrid forms of painting and sculpture—for example, the combine paintings of Robert Rauschenberg and the early work of Jasper Johns. In the realm of abstraction it has led to the assembled, projecting multileveled panels of Ellsworth Kelly, Elizabeth Murray, and Sean Scully. And it has prompted a species of abstract relief painting whose raised elements are allied to the flat plane and pictorial interests of painting, a phenomenon that first appeared in the early relief constructions of Frank Stella and in the first relief paintings of Rothschild, both of which date to the early 1970s. Since this time a major sampling of American abstraction has projected imagery out from the traditional flat surface of the canvas support, taking on a three-dimensional character.

Although relationships can be drawn between Rothschild's paintings and Post-Minimalist developments in abstraction of the later 1970s and early 1980s, in terms of both relief elements and expressive interpretations of nature, her works still stand essentially apart. Rothschild's paintings evade neat historical categorization. Without the ironic appropriations of Postmodernism, Rothschild's relief paintings sustain, extend, and illuminate the traditions of early modernism. Although they are never representational or anecdotal, allusive motifs unfold to paraphrase organic forms. Many titles of the relief paintings reflect the artist's widely ranging sources of inspiration. Some are contemporary novelists and poet-friends, such as Weldon Kees, Stanley Kunitz, and Malcolm Lowry. Some, such as Pablo Neruda, William Butler Yeats, and James Joyce, are poets whose courage and eloquence have moved Rothschild. Her mythological titles, Homeric or Joycean, arise from a concern to focus attention on the evocative power of form. The relief paintings spring from a more genuine classical aesthetic than does most of mainstream contemporary art. Having come to realize that the underlying principle of Rothschild's art is the coordination of sensual shape and a classicizing pictorial space, the viewer is led from relief to relief, as they develop from the early 1970s to the present, with an astonishment at their range and at the elegant passion the artist has evoked from the ancient medium of painting.

Rothschild resettled in New York City in the early 1970s and took the position of artist-in-residence at Syracuse University in upstate New York. It was during her tenure at Syracuse that she made her first relief painting, entitled *Frieze* (no. 1), from white rag board. She fixed irregularly shaped relief forms to a rectangular panel, over both of which she drew a continuous, meandering black ink line that echoed the contours of the raised elements. Rothschild would soon turn to foam board, a relatively new material, because of its ease of handling. Primed with white acrylic and toughened with plaster, foam board would serve as support and relief element until 1986. Following *Frieze* she began to include color by collaging colored paper shapes and grounds to the foam-board panels.

To create the relief elements for the paintings she executed until the mid-1980s, Rothschild took primed foam-board panels and drew on them in pencil. After retracing the penciled forms with black paint, she cut them out, loosely following her contour drawing as a guide and establishing with the rotation of her wrists a beveled or straight edge. The physical delight Rothschild says she took in cutting lines through the foam board with a razor, wielding it as she would a pencil, betrays her innate linear sensibility.

The cut edge and drawn line that Rothschild created are calligraphic and fluid. She contrived their animation with no less cunning than the perpetrated liveliness of Henri Matisse's linear arabesques. The apparently random free line, retained in the cutout shapes while never precisely outlining them, suggests a continuity of forms not encompassed by the actual boundaries of the relief elements. In retrospect this fluid relationship of shape and contour was grounded in Rothschild's work previous to the relief paintings. *Interior* of 1970 (p. 25), one of Rothschild's last stretched-canvas paintings, shows the elusive linear scaffolding for form that will play a central role in the dialogue between line and edge in the early relief paintings.

Rothschild's paintings of the 1970s have a twofold resolution of abstract form—one suggestively figurative and natural, the other cryptic. Never conceived as nonobjective —that is, independent of all associations—the relief paintings of this period exhibit the range of abstracted form that marked the artist's earlier work, although here explored within the new context of foam-board relief. In the first group title and form suggest landscapes that are uninhabited or marked by lonely presences. The geography is the seashore, reflecting Rothschild's stays on California's Big Sur and on Massachusetts's Cape Cod, where she had lived in the later 1960s and where she now summered. Bathers cavort with one another against a horizon line in *Scene I* and *Scene II* (nos. 15 and 16). Beach grass is prominent in *Cape Scene I* and *Landscape II* (nos. 5 and 8), as is a cloud in *New Beach* (no. 2).

In the second group of paintings—including, for example, *Alcestis I* (no. 6) and *Cereus II* (no. 13)—shore allusions give way to leaner forms, which if more abstract still pulsate with an inner life. Leaf and pod shapes balance in acrobatic tableaux. Forms are larger and sometimes seem to fill the space, their energy absorbing the drama of the surface as they press or threaten or stand poised against one another. Frequently they seem to flatten and obliterate the surrounding space, whose color makes a foil for the relief elements.

The "Gothic" series, with its abutted and propped boomerang shapes, conveys a metaphor of arching vaults and structural tensions. Investigating a more abstracted presentation of the relief elements, Rothschild splits organic form with a straight-edge cut in *The Gothic IV* (no. 20). In oblique reference to Gothic dissolutions of architectural masses by colored light, open form, and floating canopies of stone, she likewise subverts substantiality with radiant hues and free-floating, split shapes.

Rothschild balances the weights and spatial thrusts of form and color to create imagery that is neither flat nor inert, paralleling in her compositional decisions Mondrian's principle of a "dynamic equilibrium" of unequal parts as well as Schwitters's positioning of refuse matter in his construction collages to suggest an underlying grid. She corrals the visual and associational energies of form within an implied system of horizontals and verticals. For example, thin, propellerlike blades of yellow, red, and orange steady the oblong panel of *The Gothic I* (no. 23) and control the pressures of the animated relief elements. Just as in earlier paintings, structuring elements are established by the horizon lines of the shore landscapes and, in more abstract terms, with vertical bars and floating rectangles (see *Ogygia VI* [no. 14]).

With few exceptions the relief elements of the 1970s are primarily white. Color enters through painted grounds and collaged papers and is presented in simple trios and quartets of primaries and secondaries, mixed and juxtaposed for maximal intensity. Even when color is unsaturated and clear—for example the pale lavenders, pinks, and heliotropes of *New Beach* and *Hearing at Twilight* (no. 25)—the tones are still luminescent, their crispness heightened by the pure white of the reliefs. But however seductive, color is never simply descriptive or decorative. It always functions as an expressive and formal element, divulging Rothschild's knowing use of chromatics to articulate, expand, and order space and form. Color, for example, is often a sustained chord against which shape plays in rhythmic counterpoint.

The original character of the relief paintings of the 1970s lies in color expressiveness and disposition of forms. The world of action here is forever ebullient. With no weight of gravity to arrest their extroversion, buoyant forms are held in suspension. Bright and declarative colors in simple harmonies further the playfulness. Moreover, color of this order, when presented by Rothschild as accompaniment to bright white relief elements, evokes a Mediterranean ambience not unlike that of white stucco dwellings and marble temples set in contrast to azure skies and limpid landscape colors. In spirit and form, in setting and action, the foam-board paintings of this period are arcadian pastorals. When shape is suggestively human, it is figuratively nude in its bare whiteness. If title references to American shorelines are implicitly topical, it is the Western theme of classical bathers that the artist has contemporized and personalized. And like Matisse and other painters who have been drawn to the classical idyll, Rothschild makes positive the sensual. In paintings such as *Beach Scene*, *Scene II*, and *Bathers III* (nos. 3, 16, and 21), relief shapes embrace and melt into each other with bacchanalian abandon. Elliptical line and contour suggest the bending and stretching of limbs, the body creases of folded elbow, knee, and thigh.

The essential spirit of the relief paintings of the 1970s finds culmination in a series of monumental panels Rothschild executed in 1977. Works such as *Hearing at Twilight* and *Bathers IV* (no. 24) are summaries of concerns that she now commits to large scale. Shapes in *Hearing at Twilight* float upward in choreographed movements. Inspired by Rothschild's experience of watching seagulls circle over the dump at Wellfleet on Cape Cod, the painting connects in its title and shapes to lines from Yeats's poem "The Wild Swans at Coole":

All's changed since I, hearing at twilight,
The first time on this shore,
The bell-beat of their wings above my head,
Trod with a lighter tread.

And *Bathers IV* registers with eloquence the essentially classical pulse of Rothschild's art. With gleaming white relief forms animated yet poised within a structured ground of cobalt blue and yellow-gold rectangles, it connects in abstract terms with the high ambition of Renaissance painters to present ennobled human action in idealized landscape settings. *Bathers IV* makes claim to the tradition of the *grandes baigneuses*, its measured pageantry restating the Grand Manner of Western art within the context of twentieth-century abstraction.

During the next decade Rothschild broke new ground. Her appetite for risk and a willingness to manipulate and recast form have yielded a continuous refiguring of a basic syntax composed of organic relief elements structured by color and geometry. This diversity was established during the early 1980s by a group of paintings that redirected the landscape theme of the previous decade. The defining aspect of these paintings, informally known as the "Skywatch" series, is a collaged rectangle derived from the artist's open-horizon landscapes of the 1960s. Unlike those rectangular canvases, however, structured by a horizon line to suggest sky above and earth below and infused with radiant color and sunlight, these inserts are muted to dense blacks, grays, and earth colors brushed over whites and golds. They are also more abstract and universal: no interplay of landscape elements, no specific geography, moment in time, or weather is registered.

Relief elements in the new paintings are disparate in shape and character but on the whole less figurative than those found in the paintings of the decade before. Rothschild enlivens them either with cutout colored paper collaged underneath or—for example, in *Goose Pond* (no. 32)—with brushed color that also extends in, to the panels. The earlier disjunctions of line and edge are considerably simplified. And the relief elements no longer move across the panels in overall compositions but tend to gather in discrete clusters. They are now one family of shapes among others that include as primary foil the interior landscapes.

In various resolutions from one painting to the next, relief shapes are juxtaposed to the interior, "borrowed" landscapes. Each declares its own zone of action. While in *Southwest III* (no. 36) relief forms frame the dark rectangle, in *Winter Skywatch* (no. 38) they balance it laterally, and in *Truro VI* (no. 37) they are stacked above it in a horizontal register. The relief elements and collaged landscapes are often separated by a vertical

collaged bar of color. Acting as a broad boundary line, it too is interactive with other elements. As a vertical oblong the color bar is allied to the interior landscape as one member of an implied controlling grid for relief elements to play against, jarring the introspective mood of the landscape.

With fresh adjustments in each painting of variables including the size and shape of the rectangular landscape, the stylistic character of the relief forms, and the color treatment and positioning of both, Rothschild unifies all. As pictures within pictures, the interior landscapes declare their own autonomy in color and in being more abstract than the relief elements. The artist disciplines form rigorously to prevent the interior landscape from reading either as an ancillary abstract image or as a self-consciously pasted-on element that dominates on a secondary background of relief and color.

Rothschild disallowed any relief in *The Marsh* (no. 39) and pared down her dialectic of forms to interior landscape and color field alone. The success of her formal adjustments rests in her having mixed a deep and clear yellow-green whose weight and expanse establish a discrete abstract shape that meets the blackened landscape on its own plane without receding to the status of a simple, recessive frame of color for a centered illusionistic landscape. The risk of decorative abstraction is deftly avoided. In much the same way, a parity of elements is achieved in the "Skywatch" series, as color and relief shapes are calibrated by Rothschild to counterbalance the dark rectangles.

The expressive forms in these paintings offer contrasts that couple the geometric with the organic, stasis with movement, and emotion with restraint. The polarities also suggest mythic content. *Persephone* (no. 33) alludes in its title to ancient narratives of death and resurrection, to Hades' queen escort who returns annually to the surface of the earth to visit her mother and to bring spring. Primal contrasts are visualized here by bursting relief shapes on a verdant green, to the left, which are separated by an earth brown bar from an adjacent field of gray, to the right. The floating black rectangle carries not an abstracted horizon line but a collaged biomorphic mass with a delicate, ghostly white line tracing a cluster of fruit shapes. The solstice/equinox theme of *Persephone* is addressed again in *Skywatch VII* (no. 28), where white relief forms are silhouetted against an azure blue rectangle that is placed on a cream ground streaked with leaf green. The relief is opposed to a looming brown-black landscape to its left, the two buffered by a broadly assertive yellow-ocher bar. The menacing lateral movement of the internal landscape toward the framed relief shapes is enhanced and countered ambiguously by a slender streak of incandescent scarlet that laces the edge of the brown-black rectangle, suggesting a momentary corona of light caused by the approaching autumnal landscape that eclipses all radiance.

Notwithstanding the play of contrasts in these paintings, the emotional tenor remains subdued. Color is low-keyed. Earth tones dominate and lively relief forms are chastened. Emotional atmospheres are grayed. In the lightless expanses of their dark interior landscapes and in the twilight surrounds of color, these nocturnes are nearly brooding in a melancholy that is temperamentally different from the pastoral reliefs of the 1970s. Elegiac in mood, they are furthermore statements of nature made sublime in their vast, contemplative expanses, recalling the engulfing immensity of Albert Pinkham Ryder's open seas. The interior landscapes are intentionally indeterminate geographies, either

land or water, resting beneath unimpeded spaces. During her earlier travels between the two American coasts, Rothschild crossed the United States a number of times, becoming familiar with what for a New Yorker seemed almost limitless stretches of plains. These experiences, along with her intimate familiarity with the oceanic expanses off Big Sur and Cape Cod, are reflected in the ''Skywatch'' paintings. In their infinities of space, they are without doubt her most romantic works to date.

By the mid-1980s, having established a format that evolved out of the ''Skywatch'' paintings, Rothschild began to make a more direct presentation of dialectical forms. Like *Persephone*, with its boxed linear still life in immediate lateral opposition to unfolding relief forms, the new paintings straightforwardly declare their dualistic elements. This is their compositional tension. As a group they also share titles inspired by ancient Greek narratives (nos. 40–42).

In this body of work Rothschild delineated reliefs that once again paraphrase the human figure. Here they are full of energy and charged with movement. With a black line restricted to outlining the contours of raised shape rather than free in its relationship to an edge, relief is emphatic in impact. Activated relief elements are counterbalanced by equally assertive shapes and grounds. As in the ''Skywatches,'' fluid relief forms contrast with geometric forms that are most often rectangular. Now it tends to be vertical oblongs that flank the relief shapes and that frequently proliferate to become multiple color bars. Most characteristically, as in *Achilles' Dream II* (no. 40), they are scrubbed with broad smears of black, a handling of surface that may extend into the larger expanses of ground. Relief and collaged grounds in these paintings are dramatic foils to each other. Dualistic contrasts are tense standoffs of pulsing, churning forms and strong color, far removed from the solemn reciprocities of the ''Skywatches.''

Always fascinated by rich literary associations, Rothschild has been drawn particularly to Homer, through Robert Fitzgerald's translations, and to James Joyce, William Butler Yeats, and Pablo Neruda. When asked what holds these writers together for her, beyond even the evident relationship of Joyce's *Ulysses* to the narratives of Homer, Rothschild says she feels it has to do with their rootedness in the earth. When initiating a painting she acts on an inner feeling that during the course of creating the work may be verbalized by the title she selects. *Achilles and Briseis XXX* (no. 42), for example, centers on the figure of Patròklos (Patroclus), Achilles' beloved companion, who is lamented by Achilles after his death and who appears in a dream to Achilles in the penultimate book of the *Iliad* to request quick burial for secure passage to the underworld.

The tragic figure of Achilles' kind and valorous friend is the subject for another one of Rothschild's most moving relief paintings, *The Death of Patròklos* (no. 41), which epitomizes the ''Homeric'' series. In this painting a garland of relief shapes proceeds friezelike across a billowing red-carpet form that stretches at midpoint along three vertical panels of mustard yellow, purple-blue, and black. The fluttering V-shaped relief forms are joined to engender a continuous serpentine, whose cursive qualities point to the influence of Islamic calligraphy. (Rothschild's interest lies in the fluid yet controlled abstract forms of Arabic and Persian script, which she has also directly inserted into her collages with page fragments from texts.) The dramatic foil to the calligraphic relief shapes in *The Death of Patròklos* is not antithetical collaged forms but the ground itself, a triptych of color. This

sustained minor chord is as implacable as Fate. The black relief forms are disposed like shrouded mourners with outstretched arms gesticulating in grief. As another reading of these relief shapes, the blackened humanoid forms recall, in Greek vase painting, the recumbent horizontal weight of fallen heroes being carried by the twins Thanatos and Sleep to their graves, most illustriously on Euphronios's early classical red-figure krater depicting the death of Sarpedon, another slain victim in Homer's account of the Trojan War.

The material Rothschild employed for *The Death of Patròklos* is metal, not foam board or collaged papers. In 1986 she began using aluminum panels that were prepared to receive paint or were covered in canvas, to which relief shapes cut from sheet aluminum were affixed. Besides the advantages gained over foam board in permanence and ease of handling, there were aesthetic reasons for Rothschild's adoption of metal that relate to her attraction to relief painting.

During frequent visits to the Metropolitan Museum of Art as a child, Rothschild remembers finding herself drawn to works in relief—particularly to Minoan and Assyrian examples and to medieval ivory panels. Later, as a young artist, she was attracted to the shallow-carved panels and tondos of the quattrocento sculptor Desiderio da Settignano. Her studio is usually graced by numerous postcards of the bronze doors of San Zeno at Verona. In her paintings, as in ancient and Renaissance prototypes, the articulation of shape in relief sets the raised forms apart, places them in an emphatic dialogue with their flat grounds, and gives them a physicality that forces itself into our space to assume an iconic strength. The relief elements are the vital presences against which all else is played. Energy pushes and spreads to the edge of elevated form. The edge comes to have a quality that it would not have if painted. Furthermore, Rothschild places and arranges the raised shapes to echo the horizontal and vertical givens of the rectangular foam-board panels. The liveliness of the raised forms is checked and braced by the squared pictorial ground. These formal exchanges would be absent if shapes were not in relief, and thus would be forfeited a dramatic physical presence and one of the most telling ways the paintings engage the eye.

Rothschild's reliefs are allied to the pictorial realm of painting: relief forms are flat and the paintings are viewed en face. Yet the simple physical fact of relief—that it is a tangible thing in distinction to the pictorial space of the painted grounds—reaches out to the corporeal. Relief elements declare themselves as facts, whereas pictorial space is fictive. The allure of Rothschild's relief paintings lies in the simultaneous appeal to both worlds and in the manipulated tensions and mediations between them. Her shift to metal, which rivets the eye on the physicality of relief shape less ambiguously than does foam board, did not hinge, therefore, on a decorative issue nor was it ultimately a formal resolution. It reveals, rather, a breakthrough in pursuing the psychological engagement of artist and viewer in the interplay between illusion and the real.

Metal has been Rothschild's material of choice since the mid-1980s. It would be the physical basis for the two series developed during the later part of the decade and the early 1990s: the "Neruda" and "Eidolon" groups. The "Neruda" paintings, with their incorporation of friezelike relief forms and banded voids of color, sustain the pictorial character of *The Death of Patròklos* (no. 41), although relief elements are now contained in horizontal registers above and below a bisected rectangular color field. In the

"Neruda" series relief forms are both figurelike and botanical, as suggested by the green shapes of *Neruda IV* (no. 43). Shapes are edged with a black line or painted with flat color, paralleling the relief elements of the "Homeric" series. Painted in most instances with sooted blacks and purples subtly streaked with bright color, the open rectangular expanses are divided by a thin vertical line. These Minimalist color fields are the dichotomous element in the "Neruda" paintings, over and below which lively relief shapes assemble. As in *The Death of Patròklos*, the painterly treatment of pigment takes on a textural richness by its application on canvas, which, used sporadically in the "Homeric" group, becomes the defining support for the "Neruda" paintings. Color takes on a new physical dimension as Rothschild scumbles one shade over another in thin layers of paint that do not conceal the texture of woven canvas. The dualistic nature of the "Nerudas" situates itself in the play between relief and the rectangular color voids. The two zones are carefully balanced in hue, density, and proportion so that the squared fields never become neutral windows, nor do the relief forms ever dominate. As the most delicate element in the "Neruda" image and the one on which so much depends, the attenuated vertical line connects the upper and lower relief registers and stiffens the rectilinear composition. Without its mediating role the various component parts of the "Neruda" format would not cohere. The vertical simultaneously adds a strong note of tension by severing the space of the color void.

All of the "Neruda" paintings are in metal except two versions that were fabricated in 1976 and 1977 of foam board: *For Neruda I* and *For Neruda* (nos. 22 and 27). These earlier foam-board paintings lay fallow for ten years until Rothschild appropriated their imagery for the foundation of the "Neruda" variations in aluminum. As she reworked the original idea, she made significant changes. The vertical line, for example, is centered in the metal paintings for a steadied symmetrical ground that contrasts more with the spontaneity of the relief forms, which are now a poetic and lyrical foil for the cryptic center section. The later bisected rectangle is also far more developed as a painterly form and may, as in *Neruda IV* (no. 43), be bracketed only at the top with relief shapes, the lower register left free for a strong horizontal band of black beneath which the divided rectangle resumes, changed in color from casts of maroon to a deep royal blue that is bisected now with a broader yellow band.

The poet and diplomat Pablo Neruda, for whom the series is named, was awarded the Nobel Prize for literature in 1973 while serving as the Chilean ambassador to France. His poetic imagination was connected to the land as was the imagination of the Greeks; Neruda used metaphorical and biblical allusions in his memoirs to describe nature with sharp visual detail. Rothschild's "Neruda" paintings evoke the poet's sensitivity to the natural in their earthy density of color and laureate relief forms. They also function as commemorative imagery with their squared compositional formats that speak of closed shutters and the predellas of Christian diptychs, or of classical funereal stelae. Neruda's death followed eleven days after the assassination of his close friend Salvador Allende, the president of Chile, and the fall of the leftist government to which he was committed. The threat to Chile may lie metaphorically in the color voids of the Neruda series and its antidote in the natural as expressed by the botanical relief forms. There is a deep sense of

loss in these paintings that if gently tied to the memory of a specific poet is nonetheless universal in its elegiac poignance.

In 1987 Rothschild began a group of relief paintings, wholly new in its imagery, that would become known as the "Eidolon" series. It marks her first use of a title that specifically names the relief shape, one that furthermore remains relatively constant in its contours from painting to painting. The Greek word *eidolon* refers to a small winged figure, neither quite human nor animal but phantasmagorical. Reflecting the steady move in the relief paintings toward more highly articulated surfaces and developed ambiguities, the "Eidolon" series is formally complex. Its relief element consists of two joined U-shaped forms, often centered within square formats. Generally grayed or white, it can also be painted with dappled or flat color, or in a significant departure, it can receive distinct patterns of color.

Forms in the "Eidolon" paintings are juxtaposed not laterally or vertically as in the "Skywatch," "Homeric," and "Neruda" series, but solely in terms of figure and ground. As figure the eidolon relief shape is as formally developed as the ground, narrowing the more distinct differences between relief and ground in earlier paintings. The vertical panels of color that compose the ground in the first painting of the series, *Dark Eidolon* (no. 44), will in later paintings incorporate bisected oval shapes. After *Dark Eidolon* the definitive ground is a centered black vertical bar flanked by hemi-ellipsoids. These ground and relief configurations may be, in turn, framed by half ovals or vertical bars that anchor the entire composition to either side.

Contrasting with the black and gray of centered and bracketing forms are Rothschild's daring combinations of complementary color in the grounds—particularly intermediate reds and oranges that bounce off cobalt blues and kelly greens. Her intricate grounds are further activated with passages of jotted brushwork that are looser in character than the rectangular shapes of the "Homeric" series or the color voids of the "Neruda" paintings. Although expressionist in energy, Rothschild's *tâches* are, for all their deceptive freedom, as disciplined as the rapturous color of Matisse's Fauve paintings. Her increased painterliness in the "Eidolon" series always occurs within a context of structured form. She never tyrannizes over the surface.

Relief and ground are not only raised to the same level of formal complexity in works of the 1980s, but they are also made by Rothschild more reciprocal than ever before. Similar painterly notations of paint on the grounds may be continued in relief, as they are in *Whirligig II* (no. 46), where a yellow-gold shape steps up from the metal panel to the projecting eidolon. In a departure from the artist's usual standardized muted grays and whites for the eidolon, color development is as strong in the multicolored relief shape of *Dark Eidolon III* (no. 47) as it is in the ground it rests on. Sensuous turquoises, lavenders, and golds are constituents of both. What draws relief and ground into each other's orbit most distinctively in this painting, however, is the curvilinear line of the eidolon shape, its painted forms, and the truncated ovals of the panel.

As Rothschild developed an intentional interplay between forms, figure/ground identities became more blurred and relationships more intertwined throughout this series than in earlier paintings, but never to the extent of obliterating the differences between the two. A fundamental polarity of forms remains crucial to Rothschild's abstraction in

the "Eidolon" compositions. It is sustained in most instances in the contrast between grayed relief, with its raised surface and tangible edge, and colored ground. And the expressive distinction still holds between the biomorphic liveliness of the eidolon and all else, which persists as enlivened yet inanimate geometry.

It is the elusiveness of the eidolon—its essential ambiguity—that attracted Rothschild. What is its nature? Substantial, insubstantial? Vulnerable or assertive? As visualized by Rothschild to be a spinning whirligig, is it a delicate butterfly or a menacing propeller? And what are its circumstances? Is its élan vital triumphant or endangered? Is the space it spins through an accomplice to its actions or a threat? It would seem in part to be the latter. The universe the eidolon moves through is as formidable as the dark voids of the "Neruda" paintings. Proudly iconic in its centered presentation, the airborne, celestial eidolon negotiates a chthonic realm, risking engulfment by bisected mandorlas that are pincerlike. The painted shapes on the eidolon reliefs seem not so much intrinsic qualities as partial shadows cast by looming forms passing across and sandwiching the eidolon between themselves and the ground.

In 1989, when she was evolving the "Eidolon" series, Rothschild began to rework another earlier image, as she had with the metal-relief "Nerudas." The appropriated work was *The Gothic VI* (no. 26) of 1977, and the result was a series of large-scale relief paintings, most of which nearly double the size of the original foam-board painting to monumental panels of 90×60 inches. Now realizing in color the white relief forms and ground of *The Gothic VI*, the new works have color grounds silhouetting relief shapes and in some instances making more apparent their vertical and horizontal slicing and fragmenting. Although cuts are no greater than in *The Gothic VI*, the color grounds may accentuate the dismemberment of relief shape, with remnants in certain sections taking on more autonomy.

In these later "Gothic" variations the basic shapes of the original *Gothic VI* are recognizable, although not repeated exactly. The elastic variation in their proportions is done in part to realize a unique expressive identity for each painting. It is also a function of color choice, which changes dramatically from picture to picture. The *Gothic XI* (no. 54) carries dark cobalt blue relief elements on a red ground; another, *The Gothic XIII* (no. 56), displays ivory relief shapes on a kelly green field. The color densities of these "Gothic" versions are in keeping with the rich, emotional pitch of color in the "Eidolon" series. Perhaps one of the most successful of the group, *The Gothic XII* (no. 55) proffers magenta-pink relief shapes on a pale blue-gray ground, with a blush of hot orange in one arched form and an edge of kelly green along another.

Moving away from the unmodulated whites of *The Gothic VI*, Rothschild explores more painterly surfaces in these later "Gothic" variations—surfaces that are scraped, reworked, and scumbled for chalky and tactile layerings of pigment. Color and finish carried by grounds are subtly suggested in the relief elements—for example, the mottled blues of the projecting magenta-pink shapes in *The Gothic XII* are linked to the blue-gray tonality of the ground. The new "Gothic" paintings may keep an expressive allegiance to the original foam-board painting, but as imagery is refracted through Rothschild's work of the 1980s, they cultivate a more acute emphasis on the reciprocity of relief shape and all other formal elements. Most important is the effect the artist achieves in adjusting

relief elements to their grounds so that they are not entirely independent of each other but interact in complex ways.

Because of a literal increase in scale, and because their relief forms are made incisive by crisp cut-metal edges and bold color grounds, the recent "Gothics" achieve a resolute monumentality in their essaying of architectonic form. In the forceful physicality of their shapes and surfaces, however, and in the atmospheric handling of color, these reliefs evoke the sublimity not so much of late medieval architecture as of the steeped mountainscapes of Chinese painting.

All art is a matter of adjusted tensions of form to catch and hold the eye and mind. Rothschild's relief paintings establish and weld formal polarities that may appear dualistic in nature. Sensual color and geometric under-scaffoldings, wedded together, interplay with biomorphic relief shape. The implied vitality of lifelike forms is put into literal relief as it separates from the restraining energies of painted and collaged grounds. Form is a foil to form. Elements check each other momentarily in delicate balances.

Since the first relief paintings of the early 1970s, Rothschild's ongoing exploration of these dichotomies has evolved in a particular direction. She has heightened and enriched the dualistic meaning of the work. Her theater of action is only ostensibly a world of "this against that." Form and color have become increasingly painterly and intricate in their sparrings. Motifs are more elaborate, their interplays more dramatic. If dualisms inform Rothschild's relief paintings, it is, however, difficult to see her handling of opposites as a simple pairing or harmonizing.

The terms of Rothschild's dualisms are not complementary like the coequal principles of yin and yang or Mondrian's immutable universals held in states of heroic equilibrium. Rothschild is habituated to duality, but her mediations are in precarious balance. She admits to irony and paradox. And yet the sheer aesthetic power of the relief paintings —the poignance of their carefully wrought surfaces and shapes, their elegant line and rich color—purges the emotions and consoles. There is no discouraging impasse. To make consonant what is dissonant is the resolve of mythic structures that mediate life's irreconcilables in symbolic form. It is also the stuff of Rothschild's art. The history of her relief paintings has been a story of deepening vision as she has appropriated lyrical, elegiac, and tragic modes. For Rothschild the high ambition of abstraction has been to blend ecstasy and despair, to bring them together in statements about the larger order of things. What radiates from her art is a profound and inspiriting embrace of life.

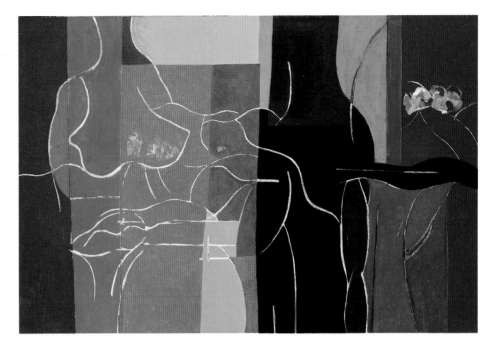

Interior, 1970; oil on canvas, 44 × 62 inches.

Checklist

1. **Frieze,** 1971
Gouache and pen and ink on Bristol board
15¾ × 29¹⁵⁄₁₆ inches

2. **New Beach,** 1973
Acrylic on foam board
27⅞ × 38 inches

3. **Beach Scene,** 1973
Acrylic on paper and foam board
30¼ × 40³⁄₁₆ inches

4. **Trees in Bloom II,** 1974
Acrylic on paper and foam board
30³⁄₁₆ × 42 inches
Collection of Mrs. Hugh Franklin, Toronto

5. **Cape Scene I,** 1974
Acrylic on paper and foam board
28⅞ × 40 inches

6. **Alcestis I,** 1974,
Acrylic on paper and foam board
39¹⁵⁄₁₆ × 59¹⁵⁄₁₆ inches

7. **Landscape I,** 1974
Acrylic on paper and foam board
30¹⁄₁₆ × 40¹⁄₁₆ inches

8. **Landscape II,** 1974
Acrylic on paper and foam board
40¼ × 60 inches
Collection of Mr. and Mrs. Roger A. Michaels,
New York

9. **False Legs Hang Down,** 1974
Acrylic on Bristol board and paper on foam
board
28 × 38⅛ inches
Private collection

10. **Ogygia I,** 1974
Acrylic on paper and foam board
40 × 60 inches

11. **Cape Scene II,** 1974
Acrylic on paper and foam board
30 × 40 inches

12. **Crazy Jane I,** 1975
Acrylic on paper and foam board
39⅝ × 59⅞ inches

13. **Cereus II,** 1975
Acrylic on paper and foam board on chipboard
29¾ × 40 inches

14. **Ogygia VI,** 1975
Acrylic on foam board
40¼ × 59⅜ inches

15. **Scene I,** 1975
Acrylic on foam board
30¹⁄₁₆ × 42¹⁄₁₆ inches
Collection of H. S. S. Miller, Philadelphia

16. **Scene II,** 1975
Acrylic on paper and foam board
40⅛ × 60⅛ inches

17. **Crazy Jane II,** 1975
Acrylic on plaster, paper, and foam board
36½ × 60¹³⁄₁₆ inches

18. **Celebration,** 1975
Acrylic on plaster, paper, and foam board
40 × 60 inches
Collection of Roy R. Neuberger, New York

19. **Ogygia II,** 1975
Acrylic on plaster, paper, and foam board
40 × 60 inches
Collection of Neuberger Museum, State
University of New York at Purchase; Gift of
Mr. and Mrs. Philip Straus, New York

20. **The Gothic IV,** 1976
Acrylic on plaster, paper, and foam board
60⅛ × 48⅞ inches

21. **Bathers III,** 1976
Acrylic on plaster and foam board
39⅝ × 59⅞ inches
Collection of Mrs. Hugh Franklin, Toronto

22. **For Neruda I,** 1976
Acrylic on plaster, paper, and foam board
48⁵⁄₁₆ × 60 inches
Collection of Mrs. Roger A. Michaels, New York

23. **The Gothic I,** 1977
Acrylic on plaster, paper, and foam board
65 × 48⅛ inches

24. **Bathers IV,** 1977
Acrylic on plaster, paper, and foam board
80⅝ × 48⅜ inches

25. **Hearing at Twilight,** 1977
Acrylic on plaster, paper, and foam board
80 × 48 inches

26. **The Gothic VI,** 1977
Acrylic on plaster, paper, and foam board
60¼ × 41⅛ inches

27. **For Neruda,** 1977
Acrylic on plaster, paper, and foam board
40½ × 36½ inches
Collection of Mr. and Mrs. John S. McDaniel, Jr.,
Baltimore

28. **Skywatch VII,** 1980
Acrylic on plaster, paper, and foam board
40⅛ × 60 inches
Collection of Provincetown Art Association and
Museum, Provincetown, Massachusetts

29. **Skywatch IX,** 1980
Acrylic on plaster, paper, and foam board
60 × 80 inches

30. **Skywatch XII,** 1980
Acrylic on plaster, paper, and foam board
59¾ × 79⅝ inches

31. **Alcestis,** 1980
Acrylic on plaster, paper, and foam board
60 × 40⅛ inches

32. **Goose Pond,** 1980
Acrylic on plaster, paper, and foam board
36¼ × 53⅛ inches
Collection of Birgitta Berglund and Pier Björn
Bäckström, Hörby, Sweden

33. **Persephone,** 1980
Acrylic on plaster, paper, and foam board
36⅜ × 48⅜ inches
Private collection

34. **Skywatch,** 1980
Acrylic on plaster, paper, and foam board
48½ × 79½ inches

35. **Skywatch III,** 1980
Acrylic on plaster, paper, and foam board
23¾ × 40 inches

36. **Southwest III,** 1981
Acrylic on plaster, paper, and foam board
39⁹⁄₁₆ × 52¹³⁄₁₆ inches

37. **Truro VI,** 1982
Acrylic on plaster, paper, and foam board
40 × 29½ inches

38. **Winter Skywatch,** 1982
Acrylic on plaster, paper, and foam board
36 × 40 inches

39. **The Marsh,** 1983
Acrylic on paper on foam board
36¼ × 48¼ inches

40. **Achilles' Dream II,** 1985
Acrylic on plaster, paper, and foam board
41 × 62 inches

41. **Death of Patròklos,** 1987
Acrylic on canvas and aluminum
26 × 44 inches

42. **Achilles and Briseis XXX,** 1987
Acrylic on canvas and aluminum on fiber glass
30 × 40 inches

43. **Neruda IV,** 1987
Acrylic on canvas and aluminum
60 × 48 inches

44. **Dark Eidolon,** 1987
Acrylic on aluminum
33 × 38¾ inches

45. **Gray Eidolon,** 1987
Acrylic on aluminum
32¾ × 38¼ inches

46. **Whirligig II,** 1989
Acrylic on aluminum
44 × 52 inches
Collection of Pennsylvania Academy of the Fine
Arts, Philadelphia

47. **Dark Eidolon III,** 1990
Acrylic and oil on canvas on aluminum
40 × 40 inches

48. **Eidolon V,** 1990
Acrylic on aluminum
44 × 52¹⁄₁₆

49. **Aegean,** 1990
Oil on aluminum
40¼ × 41¾ inches

50. **Summer Idyll-on,** 1990
Oil on aluminum
41¾ × 40¼ inches

51. **Neruda VI,** 1990
Acrylic and oil on canvas on aluminum
60 × 40 inches
Collection of the State Tretyakov Gallery,
Moscow

52. **Neruda VII,** 1990
Acrylic and oil on canvas on aluminum
60 × 40 inches

53. **The Gothic VII,** 1990
Acrylic on aluminum
60¾ × 41 inches

54. **The Gothic XI,** 1991
Acrylic on aluminum
90¼ × 60¾ inches

55. **The Gothic XII,** 1991
Acrylic on aluminum
90¼ × 60¾ inches

56. **The Gothic XIII,** 1991
Acrylic on aluminum
90¼ × 60¾ inches

Works are in the collection of the artist unless
noted otherwise.

Plate 1. **Frieze,** 1971
Gouache and pen and ink on Bristol board
15¾ × 29¹⁵⁄₁₆ inches

Plate 2. **New Beach,** 1973
Acrylic on foam board
27⅞ × 38 inches

29

Plate 3. **Beach Scene,** 1973
Acrylic on paper and foam board
30¼ × 40³⁄₁₆ inches

Plate 4. **Trees in Bloom II,** 1974
Acrylic on paper and foam board
30³⁄₁₆ × 42 inches
Collection of Mrs. Hugh Franklin, Toronto

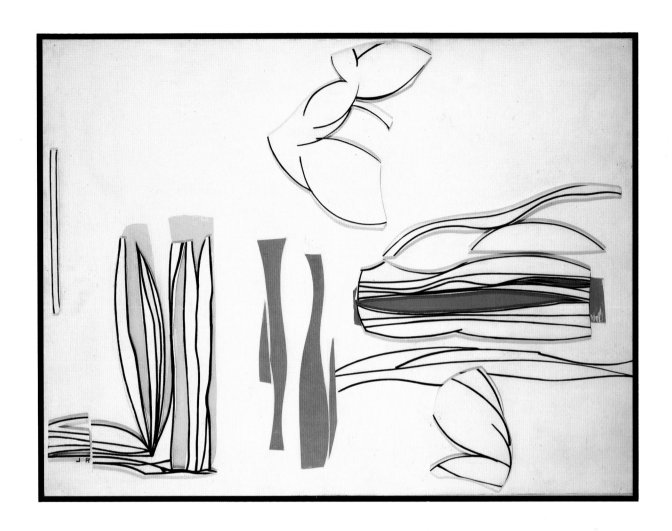

Plate 5. **Cape Scene I,** 1974
Acrylic on paper and foam board
28⅞ × 40 inches

Plate 6. **Alcestis I,** 1974,
Acrylic on paper and foam board
39¹⁵⁄₁₆ × 59¹⁵⁄₁₆ inches

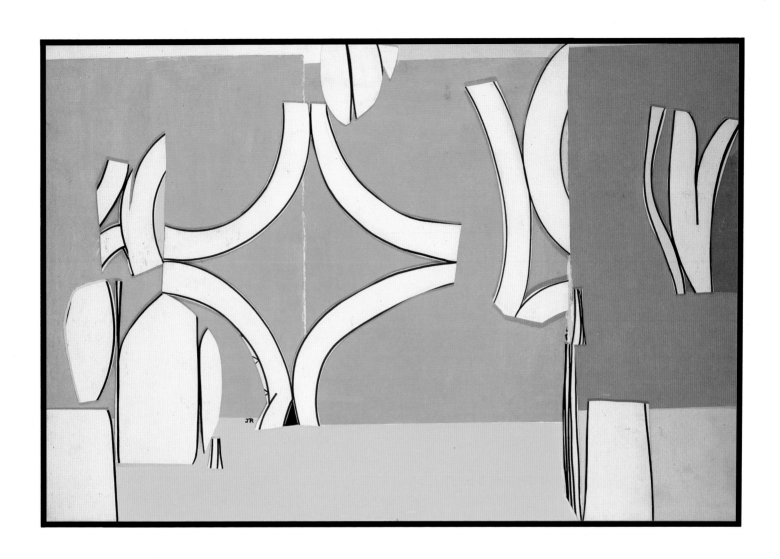

33

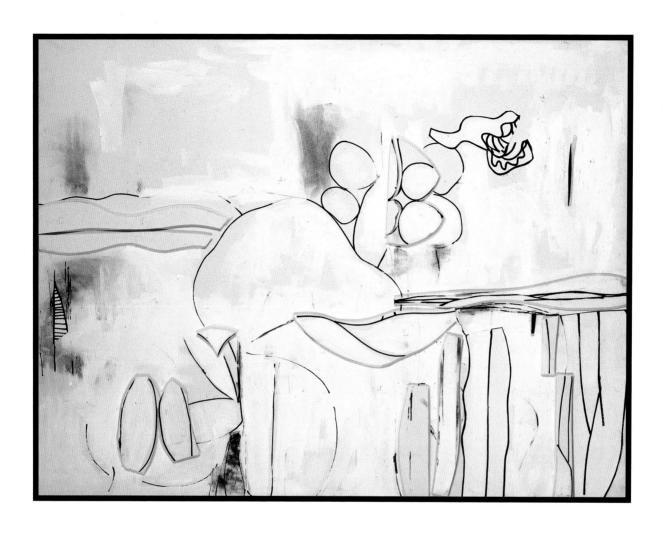

Plate 7. **Landscape I,** 1974
Acrylic on paper and foam board
30 1/16 × 40 1/16 inches

Plate 9. **False Legs Hang Down,** 1974
Acrylic on Bristol board and paper on foam
board
28 × 38 1/8 inches
Private collection

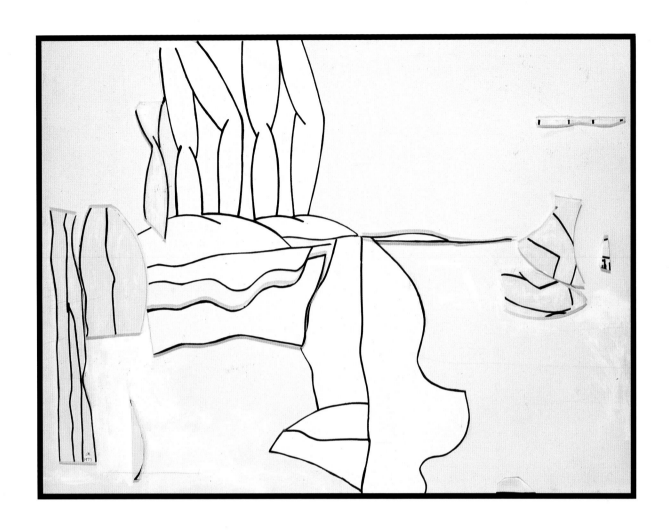

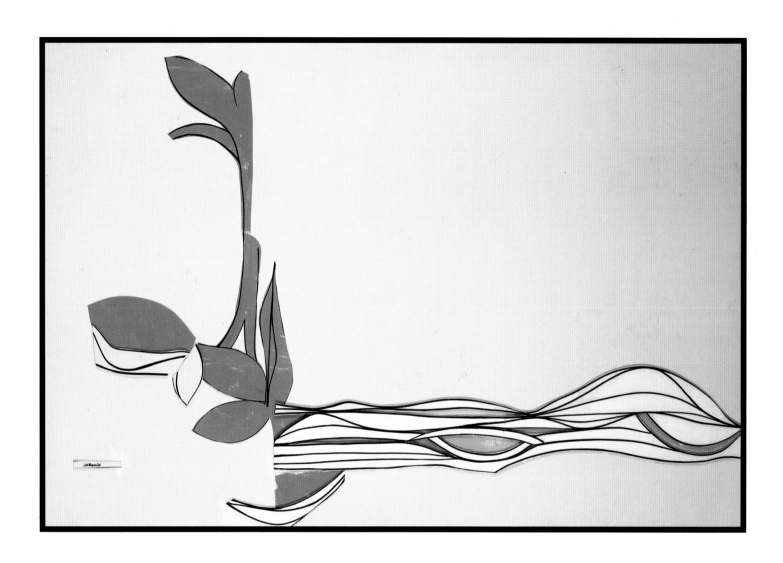

Plate 8. **Landscape II,** 1974
Acrylic on paper and foam board
40¼ × 60 inches
Collection of Mr. and Mrs. Roger A. Michaels,
New York

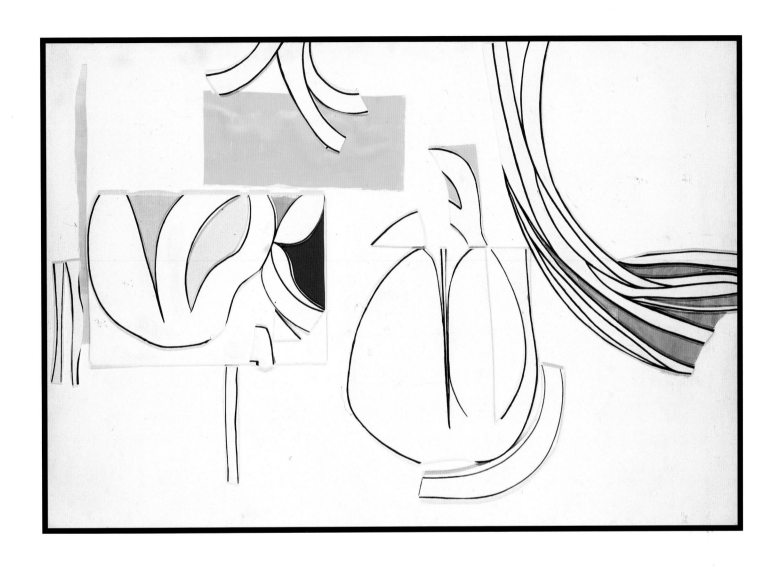

Plate 10. **Ogygia I,** 1974
Acrylic on paper and foam board
40 × 60 inches

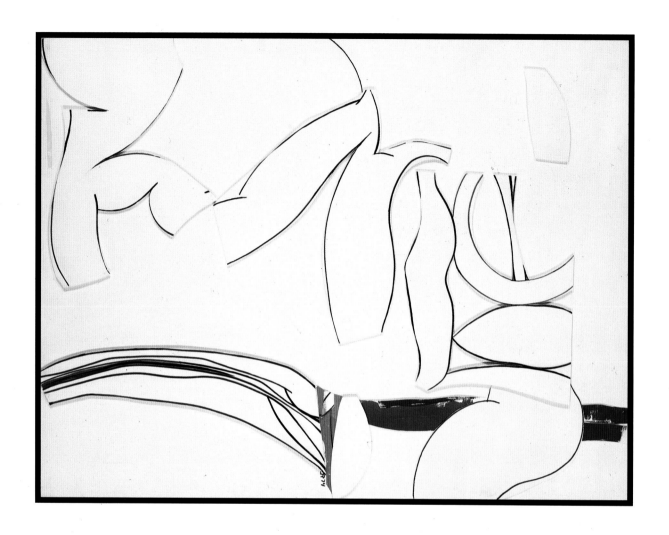

Plate 11. **Cape Scene II,** 1974
Acrylic on paper and foam board
30 × 40 inches

Plate 12. **Crazy Jane I,** 1975
Acrylic on paper and foam board
39⅝ × 59⅞ inches

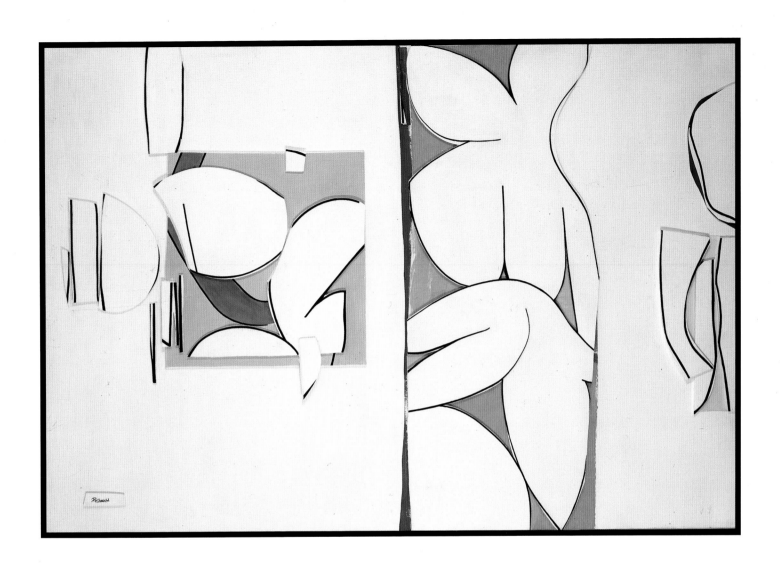

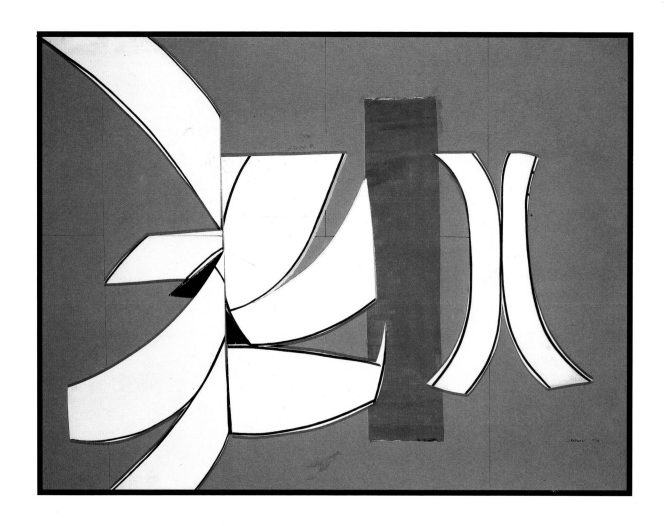

Plate 13. **Cereus II,** 1975
Acrylic on paper and foam board on chipboard
29¾ × 40 inches

Plate 14. **Ogygia VI,** 1975
Acrylic on foam board
40¼ × 59⅜ inches

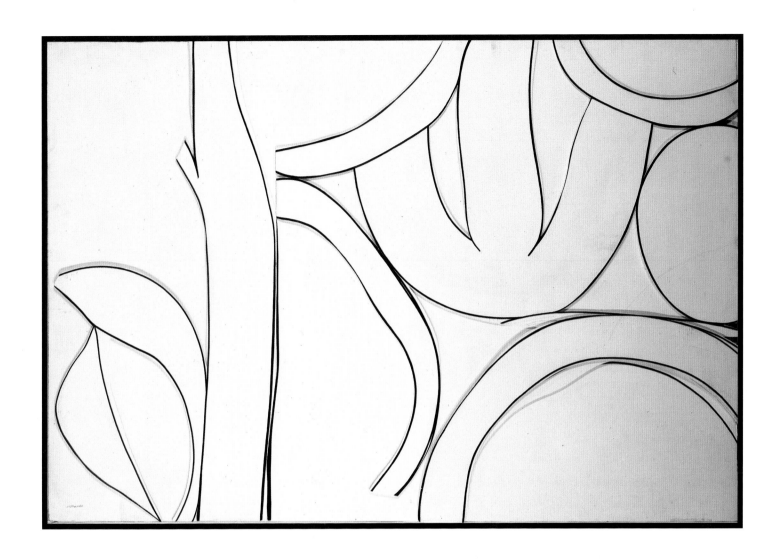

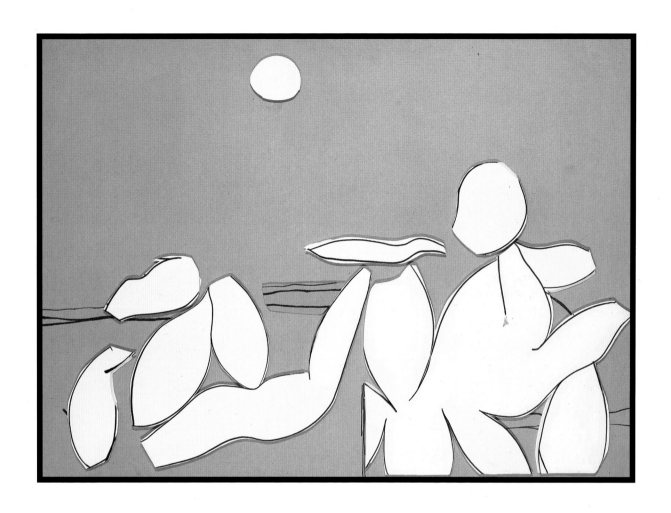

Plate 15. **Scene I,** 1975
Acrylic on foam board
30 1/16 × 42 1/16 inches
Collection of H. S. S. Miller, Philadelphia

Plate 16. **Scene II,** 1975
Acrylic on paper and foam board
40 1/8 × 60 1/8 inches

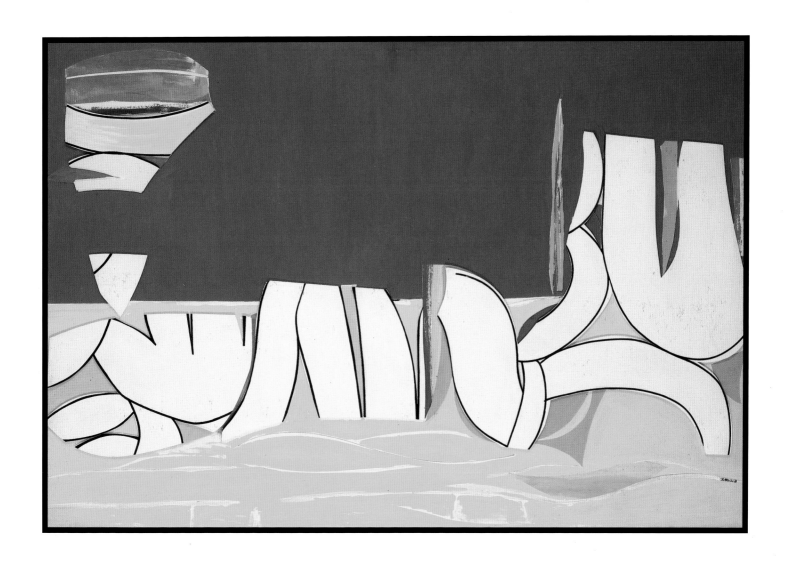

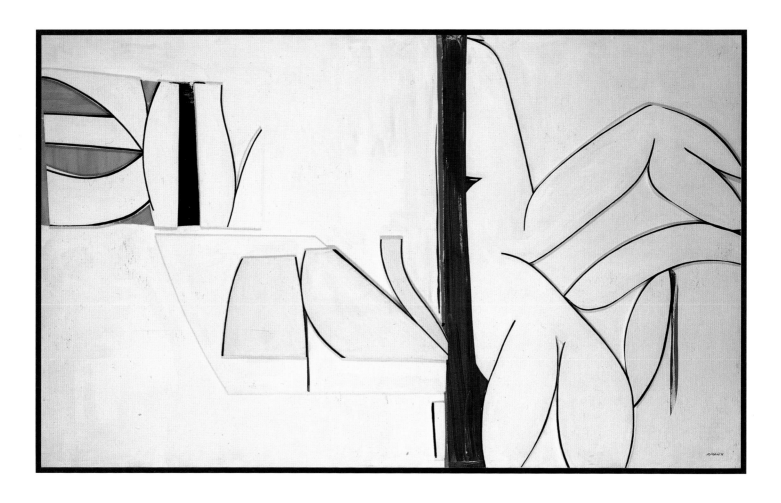

Plate 17. **Crazy Jane II,** 1975
Acrylic on plaster, paper, and foam board
36½ × 60¹³⁄₁₆ inches

Plate 18. **Celebration,** 1975
Acrylic on plaster, paper, and foam board
40 × 60 inches
Collection of Roy R. Neuberger, New York

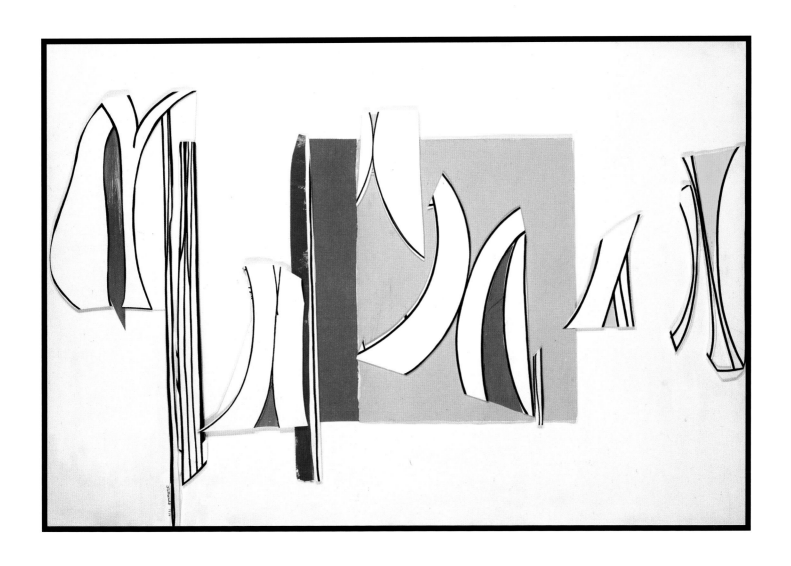

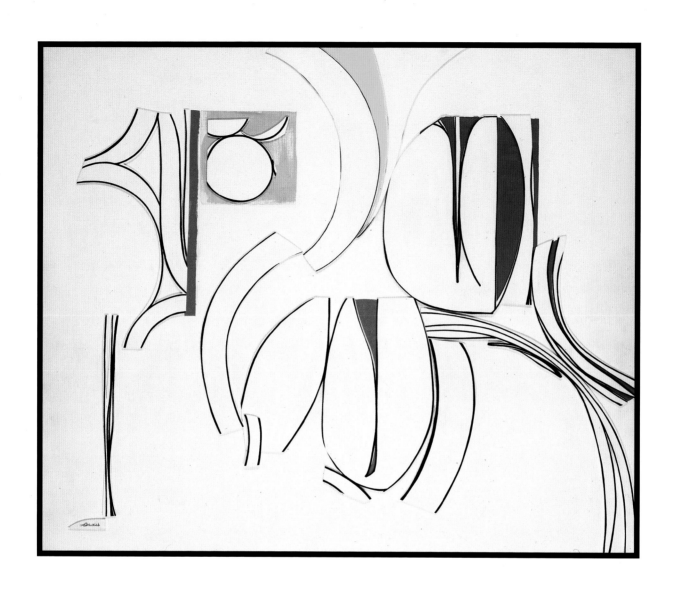

Plate 19. **Ogygia II,** 1975
Acrylic on plaster, paper, and foam board
40 × 60 inches
Collection of Neuberger Museum, State
University of New York at Purchase; Gift of
Mr. and Mrs. Philip Straus, New York

Plate 20. **The Gothic IV,** 1976
Acrylic on plaster, paper, and foam board
60⅛ × 48⅞ inches

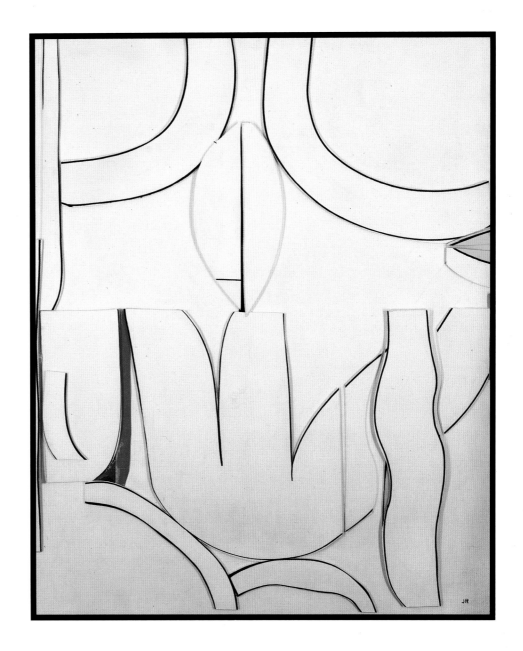

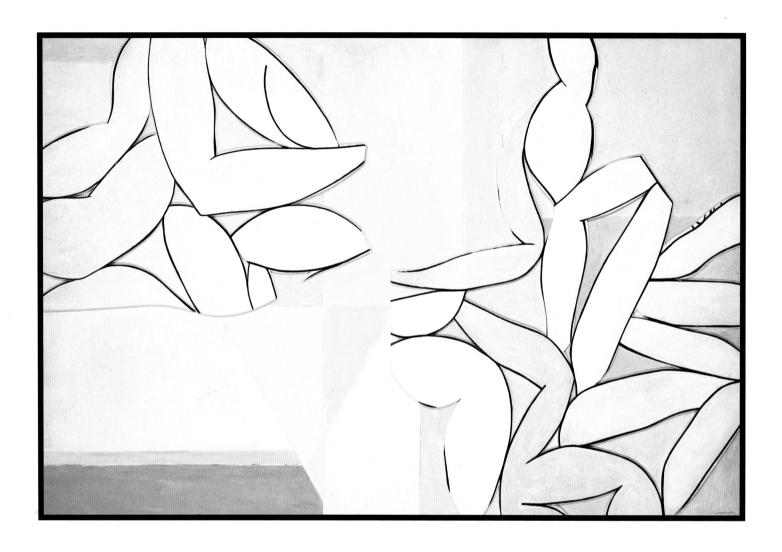

Plate 21. **Bathers III,** 1976
Acrylic on plaster and foam board
39⅝ × 59⅞ inches
Collection of Mrs. Hugh Franklin, Toronto

Plate 22. **For Neruda I,** 1976
Acrylic on plaster, paper, and foam board
48⁵⁄₁₆ × 60 inches
Collection of Mrs. Roger A. Michaels, New York

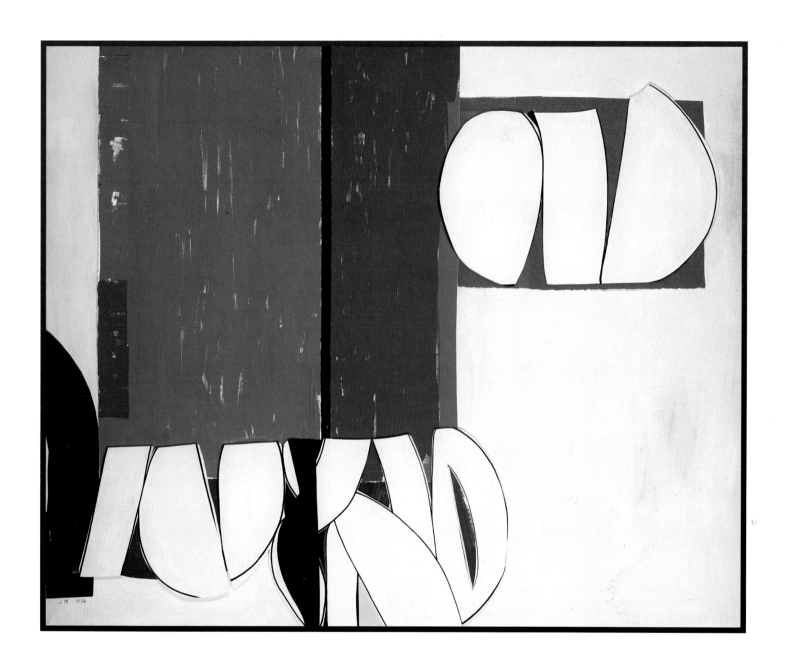

49

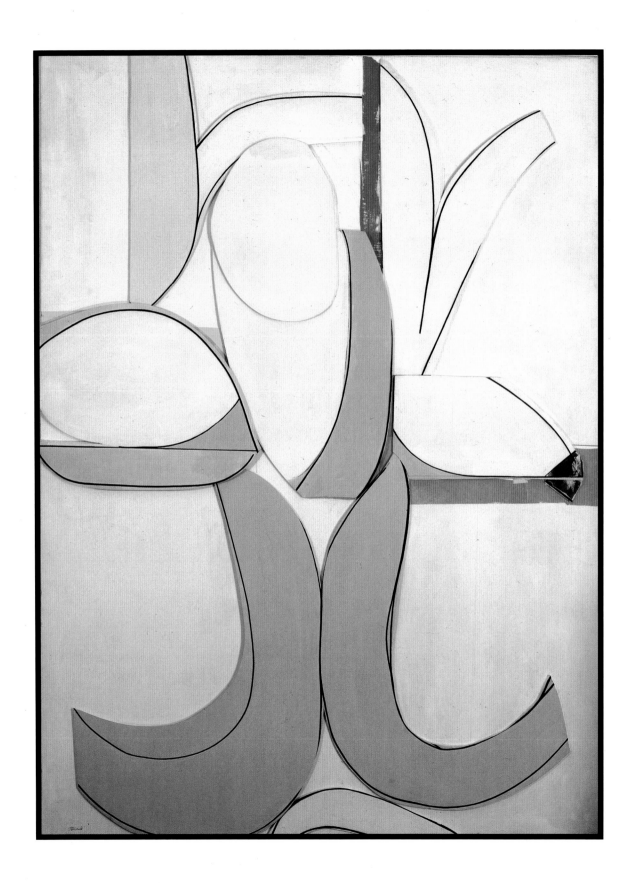

Plate 23. **The Gothic I,** 1977
Acrylic on plaster, paper, and foam board
65 × 48⅛ inches

Plate 24. **Bathers IV,** 1977
Acrylic on plaster, paper, and foam board
80⅝ × 48⅜ inches

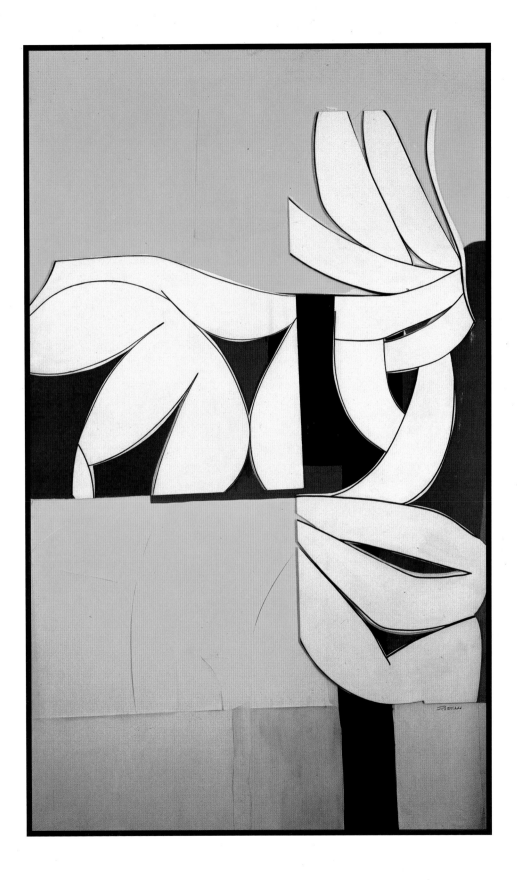

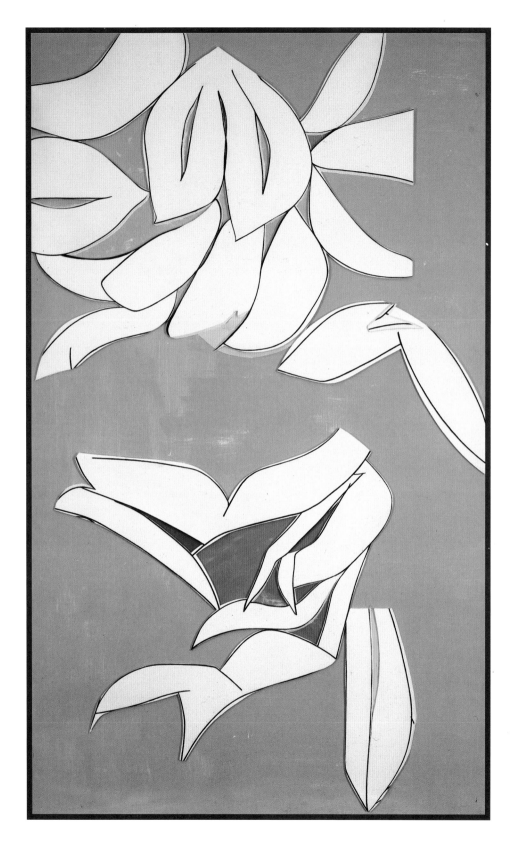

Plate 25. **Hearing at Twilight,** 1977
Acrylic on plaster, paper, and foam board
80 × 48 inches

Plate 26. **The Gothic VI,** 1977
Acrylic on plaster, paper, and foam board
60¼ × 41⅛ inches

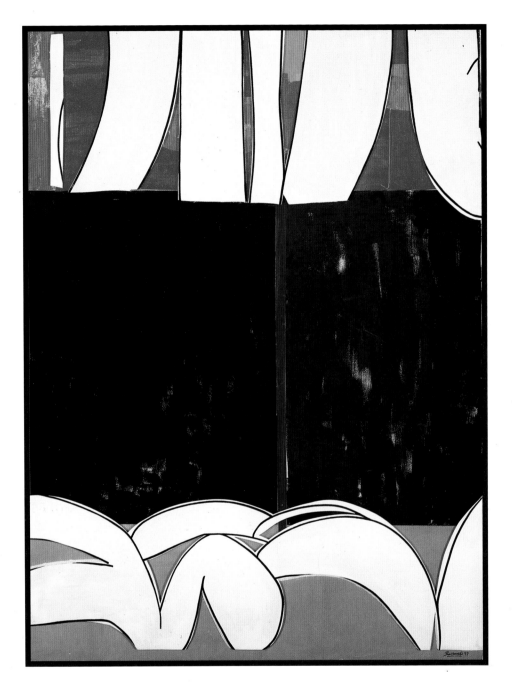

Plate 27. **For Neruda,** 1977
Acrylic on plaster, paper, and foam board
40½ × 36½ inches
Collection of Mr. and Mrs. John S. McDaniel, Jr.,
Baltimore

Plate 28. **Skywatch VII,** 1980
Acrylic on plaster, paper, and foam board
40⅛ × 60 inches
Collection of Provincetown Art Association and
Museum, Provincetown, Massachusetts

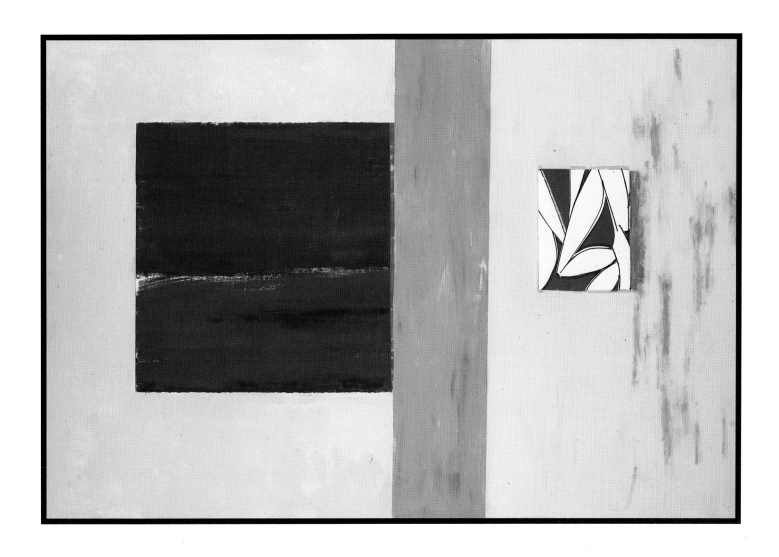

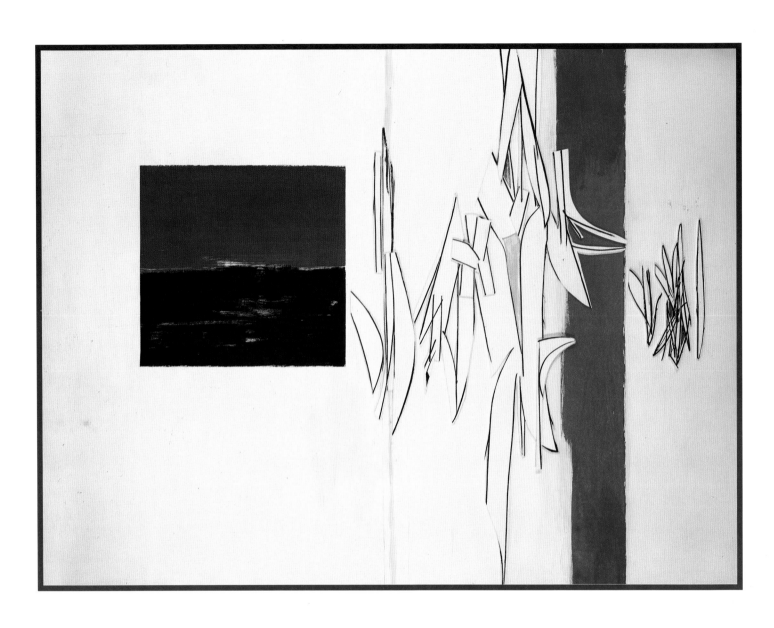

Plate 29. **Skywatch IX,** 1980
Acrylic on plaster, paper, and foam board
60 × 80 inches

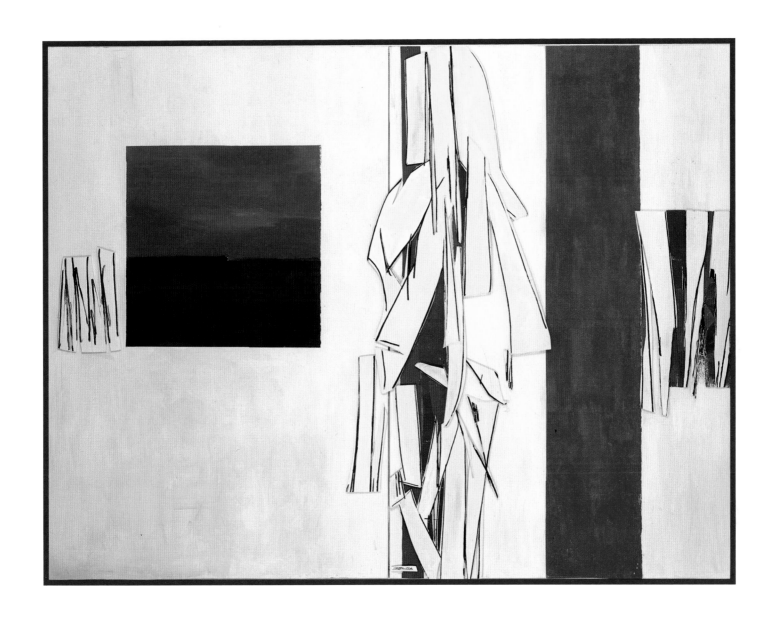

Plate 30. **Skywatch XII,** 1980
Acrylic on plaster, paper, and foam board
59¾ × 79⅝ inches

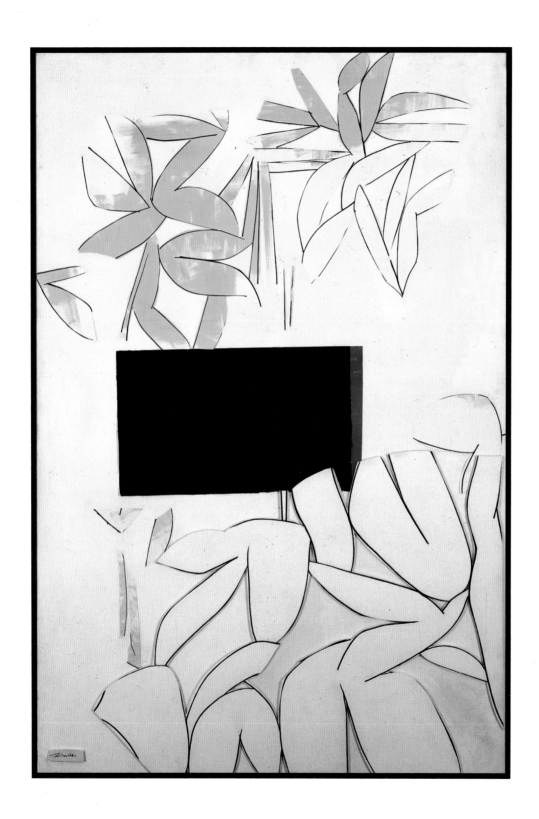

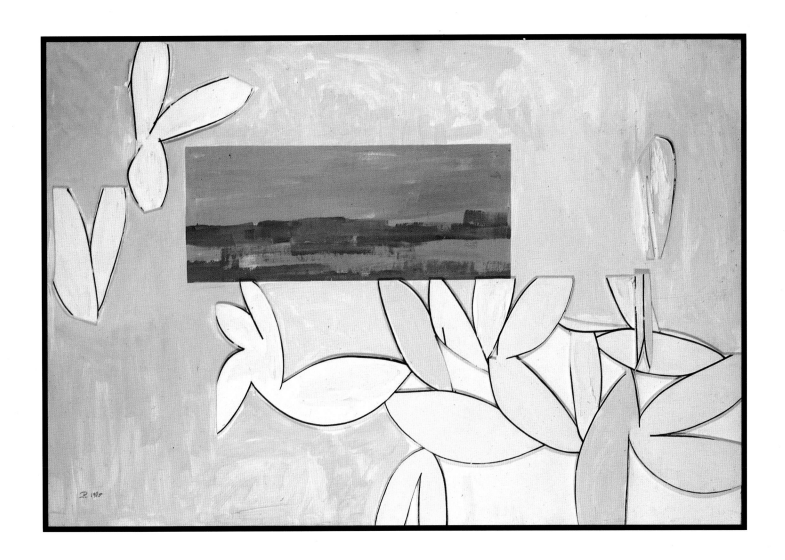

Plate 31. **Alcestis,** 1980
Acrylic on plaster, paper, and foam board
60 × 40⅛ inches

Plate 32. **Goose Pond,** 1980
Acrylic on plaster, paper, and foam board
36¼ × 53⅛ inches
Collection of Birgitta Berglund and Pier Björn
Bäckström, Hörby, Sweden

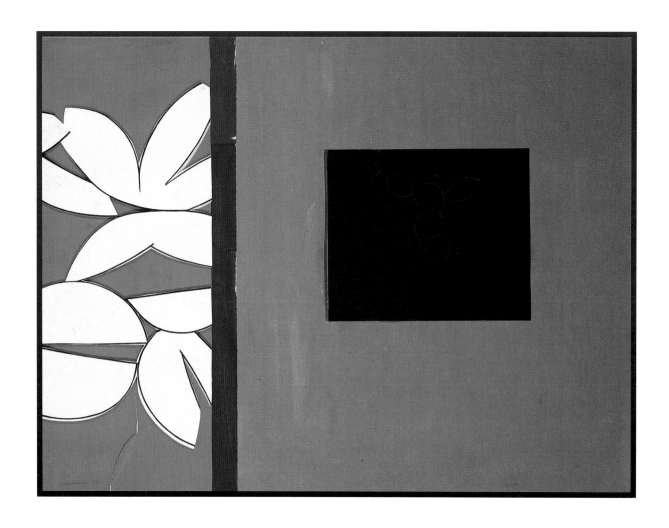

Plate 33. **Persephone,** 1980
Acrylic on plaster, paper, and foam board
36⅜ × 48⅜ inches
Private collection

Plate 34. **Skywatch,** 1980
Acrylic on plaster, paper, and foam board
48½ × 79½ inches

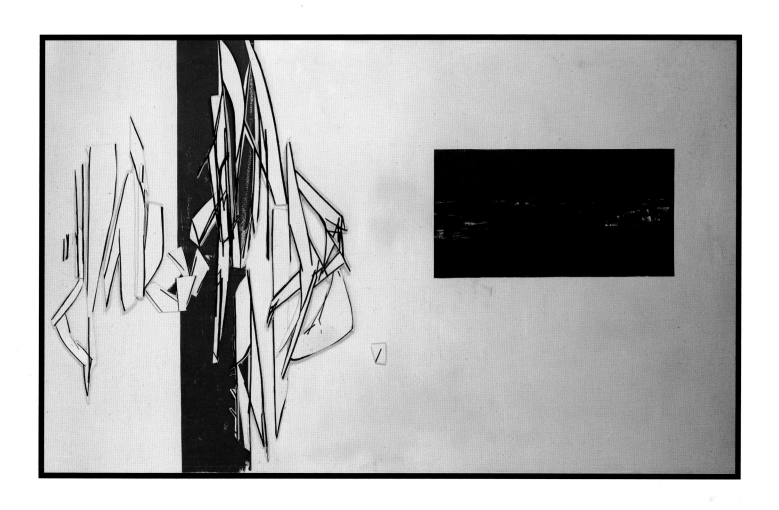

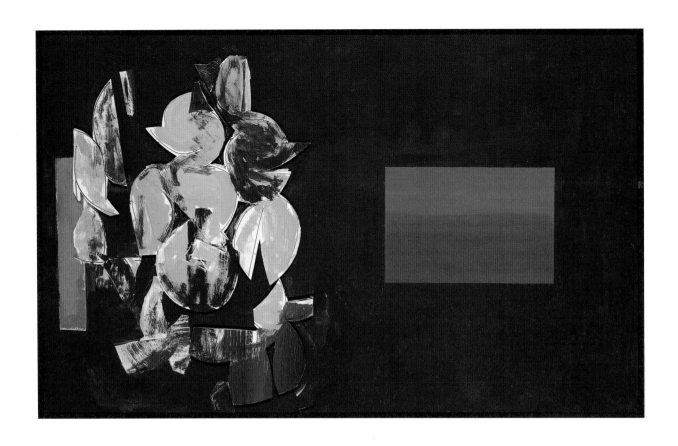

Plate 35. **Skywatch III,** 1980
Acrylic on plaster, paper, and foam board
23¾ × 40 inches

Plate 36. **Southwest III,** 1981
Acrylic on plaster, paper, and foam board
39⁹⁄₁₆ × 52¹³⁄₁₆ inches

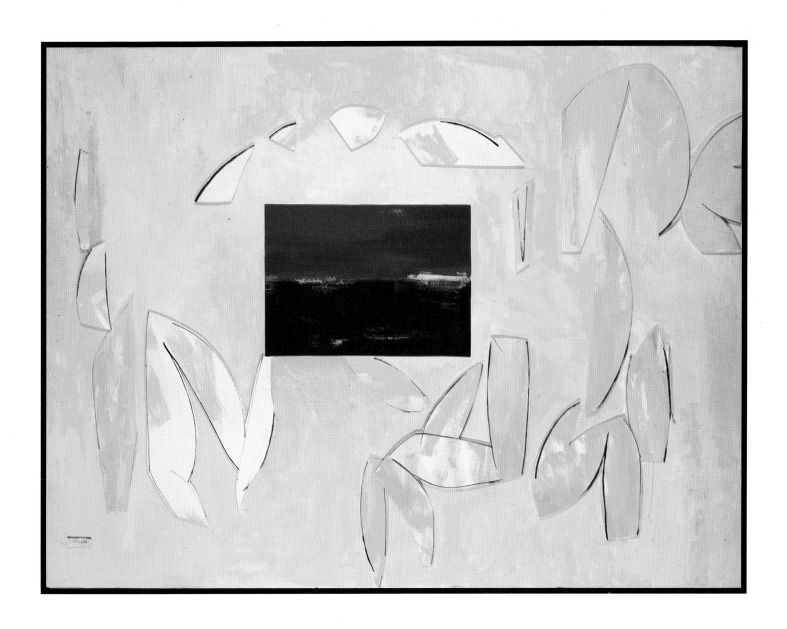

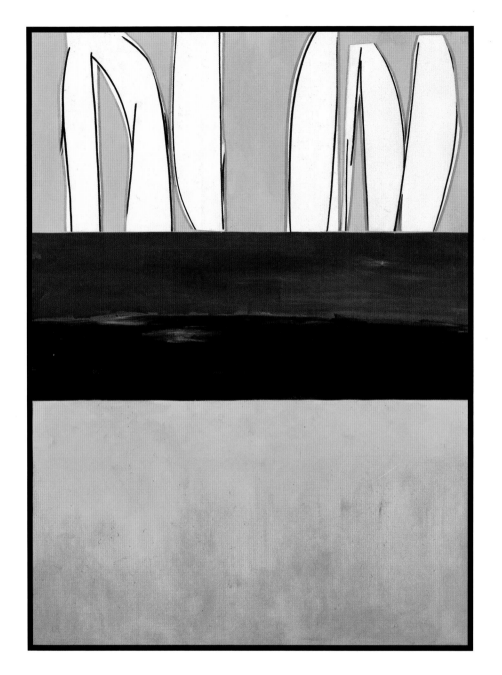

Plate 37. **Truro VI,** 1982
Acrylic on plaster, paper, and foam board
40 × 29½ inches

Plate 38. **Winter Skywatch,** 1982
Acrylic on plaster, paper, and foam board
36 × 40 inches

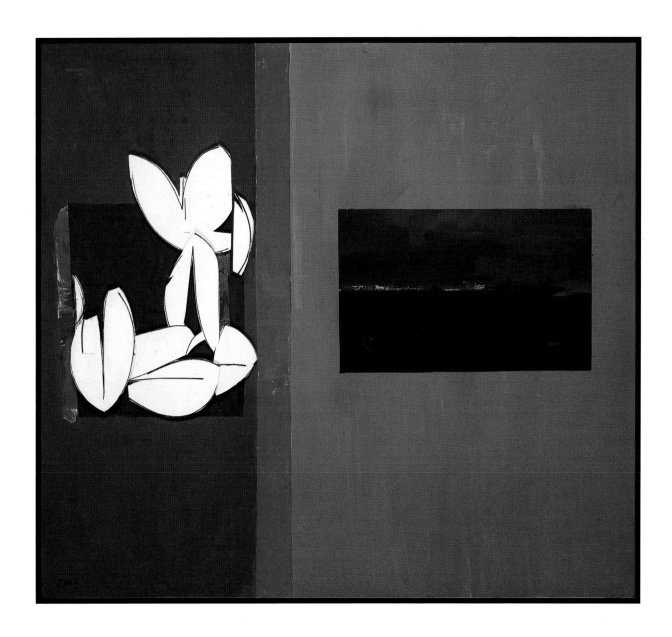

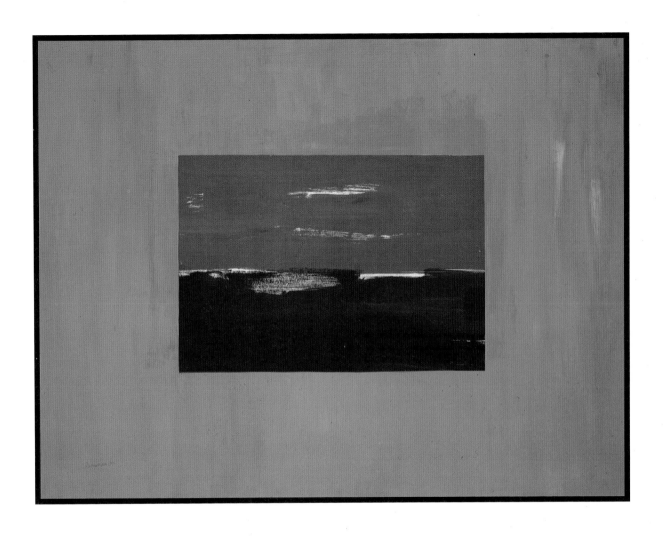

Plate 39. **The Marsh,** 1983
Acrylic on paper on foam board
36¼ × 48¼ inches

Plate 40. **Achilles' Dream II,** 1985
Acrylic on plaster, paper, and foam board
41 × 62 inches

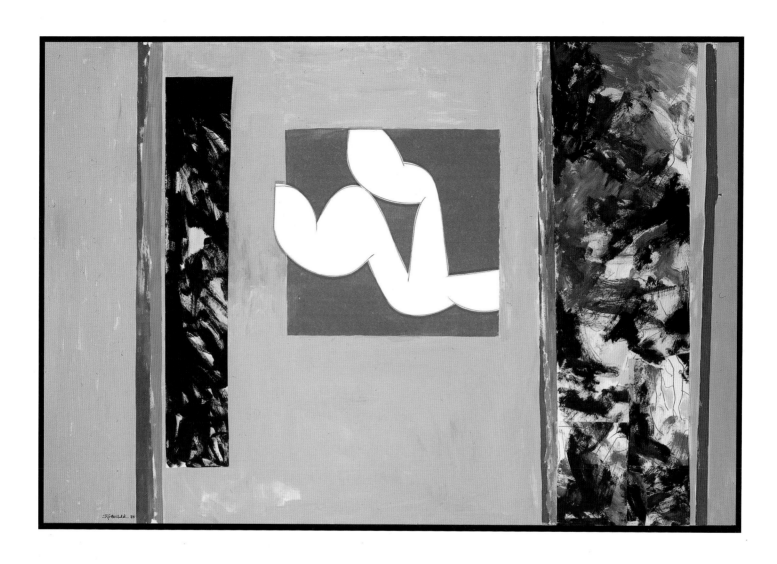

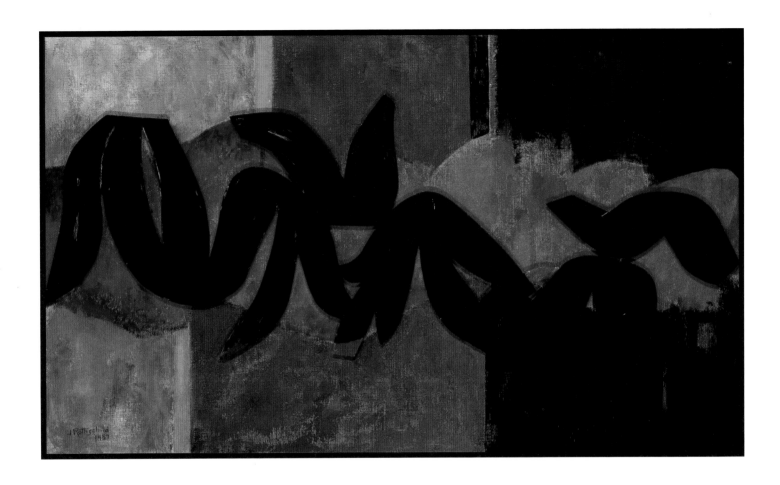

Plate 41. **Death of Patròklos,** 1987
Acrylic on canvas and aluminum
26 × 44 inches

Plate 42. **Achilles and Briseis XXX,** 1987
Acrylic on canvas and aluminum on fiber glass
30 × 40 inches

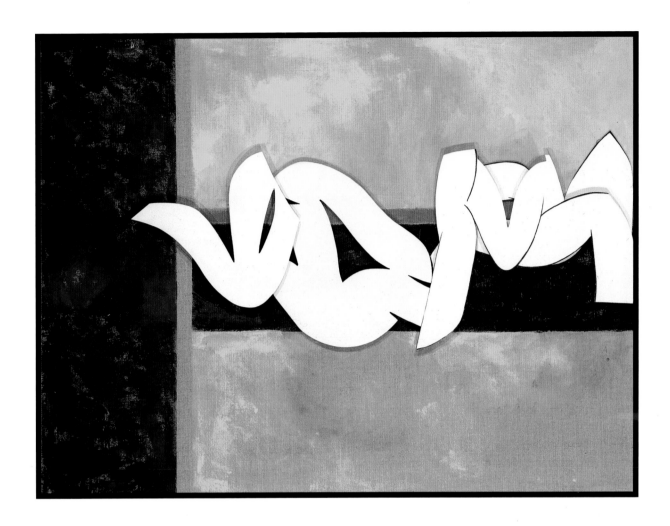

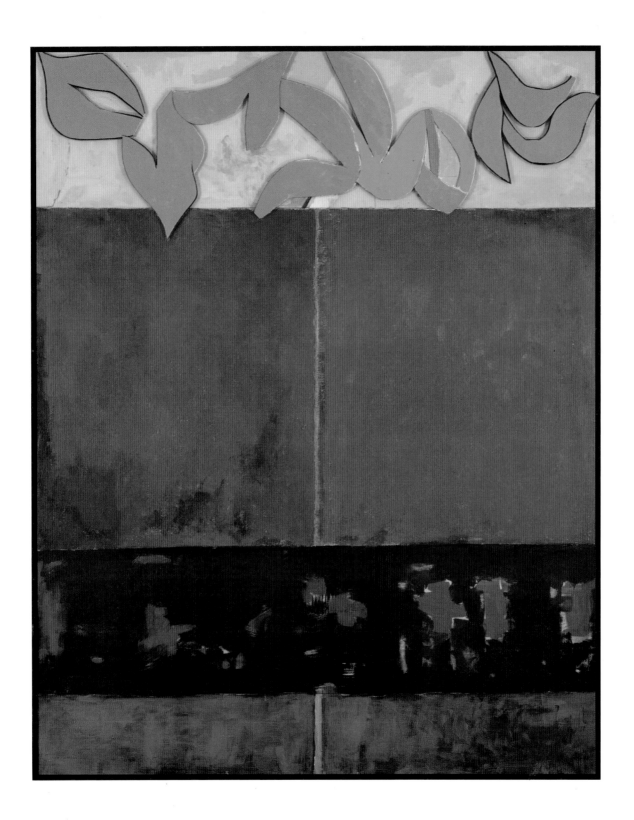

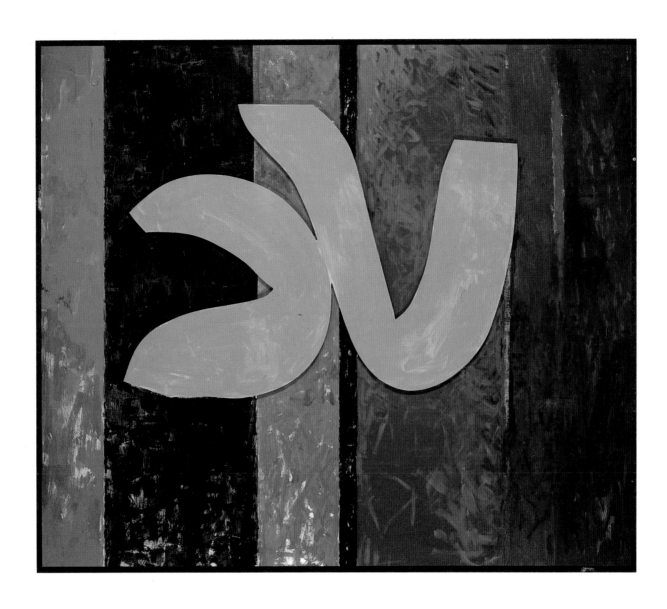

Plate 43. **Neruda IV,** 1987
Acrylic on canvas and aluminum
60 × 48 inches

Plate 44. **Dark Eidolon,** 1987
Acrylic on aluminum
33 × 38¾ inches

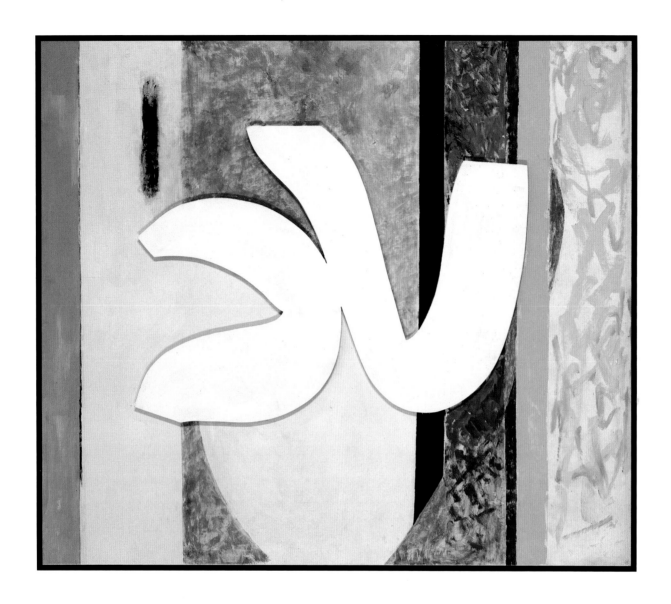

Plate 45. **Gray Eidolon,** 1987
Acrylic on aluminum
32¾ × 38¼ inches

Plate 46. **Whirligig II,** 1989
Acrylic on aluminum
44 × 52 inches
Collection of Pennsylvania Academy of the Fine
Arts, Philadelphia

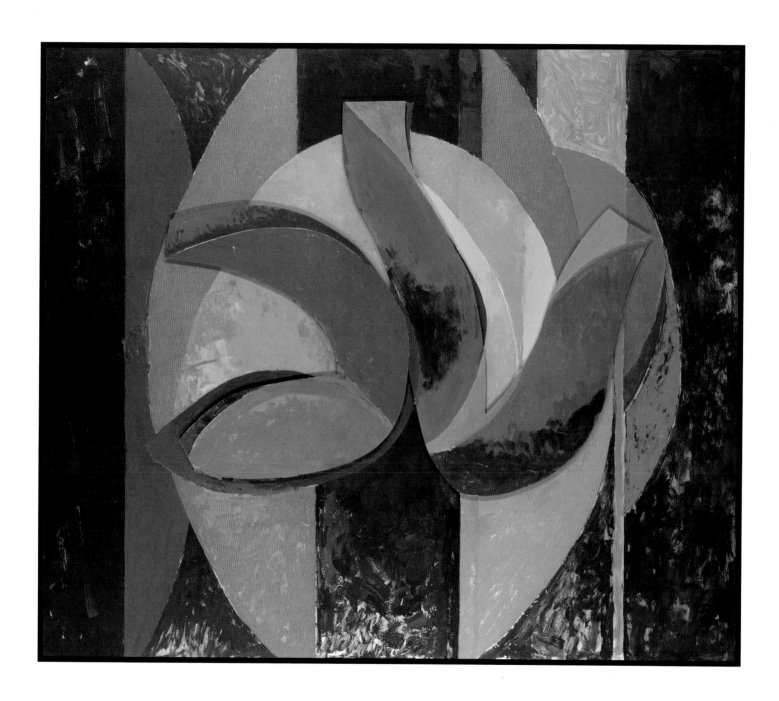

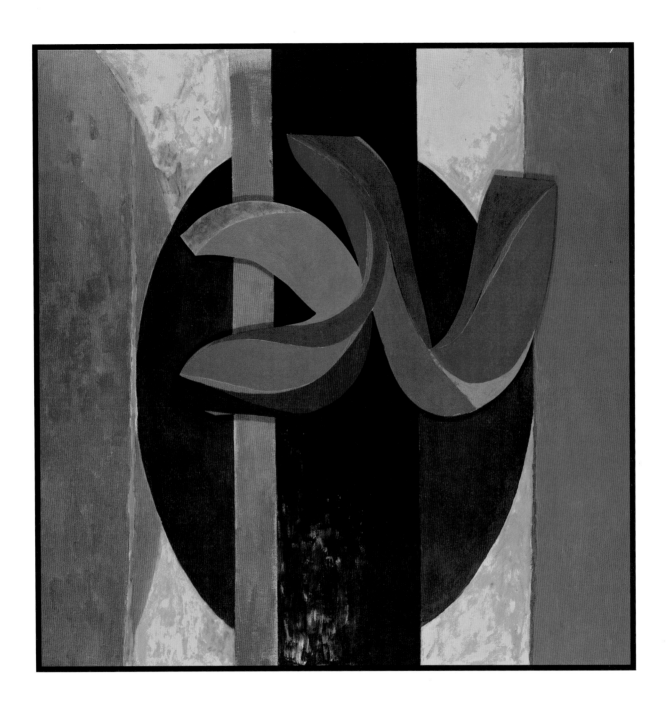

Plate 47. **Dark Eidolon III,** 1990
Acrylic and oil on canvas on aluminum
40 × 40 inches

Plate 48. **Eidolon V,** 1990
Acrylic on aluminum
44 × 52¹⁄₁₆

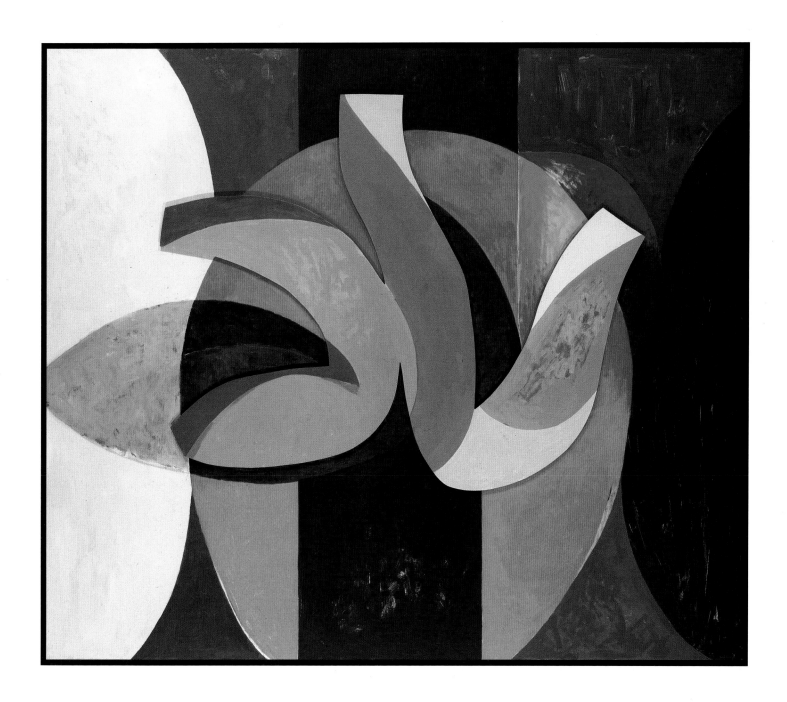

Plate 49. **Aegean,** 1990
Oil on aluminum
40¼ × 41¾ inches

Plate 50. **Summer Idyll-on,** 1990
Oil on aluminum
41¾ × 40¼ inches

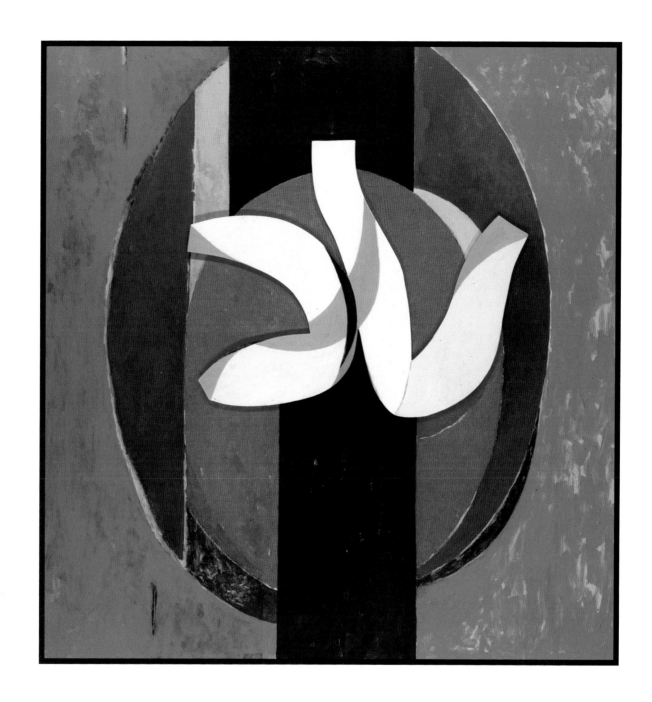

Plate 51. **Neruda VI,** 1990
Acrylic and oil on canvas on aluminum
60 × 40 inches
Collection of the State Tretyakov Gallery,
Moscow

Plate 52. **Neruda VII,** 1990
Acrylic and oil on canvas on aluminum
60 × 40 inches

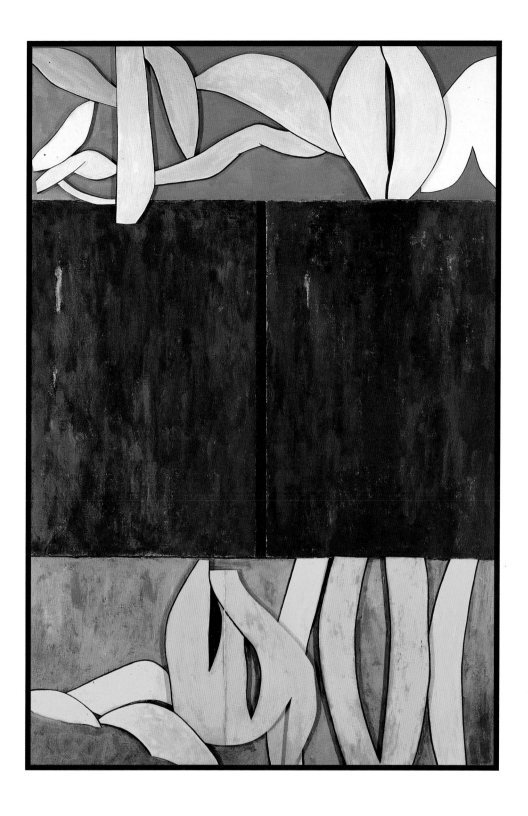

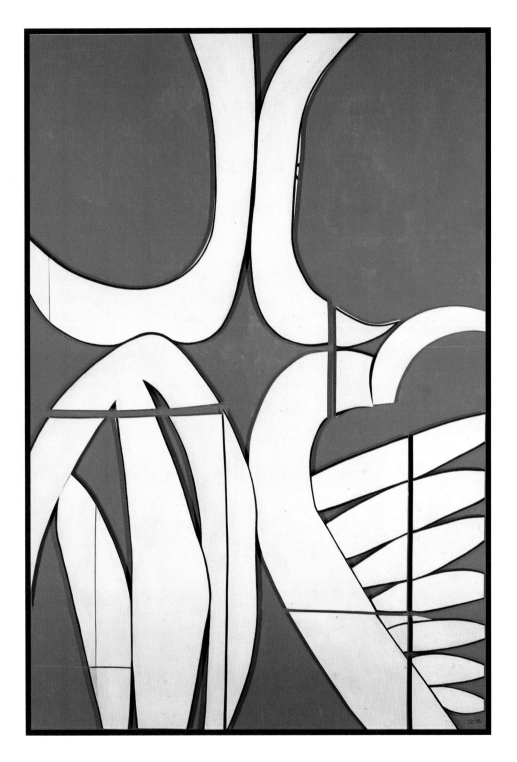

Plate 53. **The Gothic VII,** 1990
Acrylic on aluminum
60¾ × 41 inches

Plate 54. **The Gothic XI,** 1991
Acrylic on aluminum
90¼ × 60¾ inches

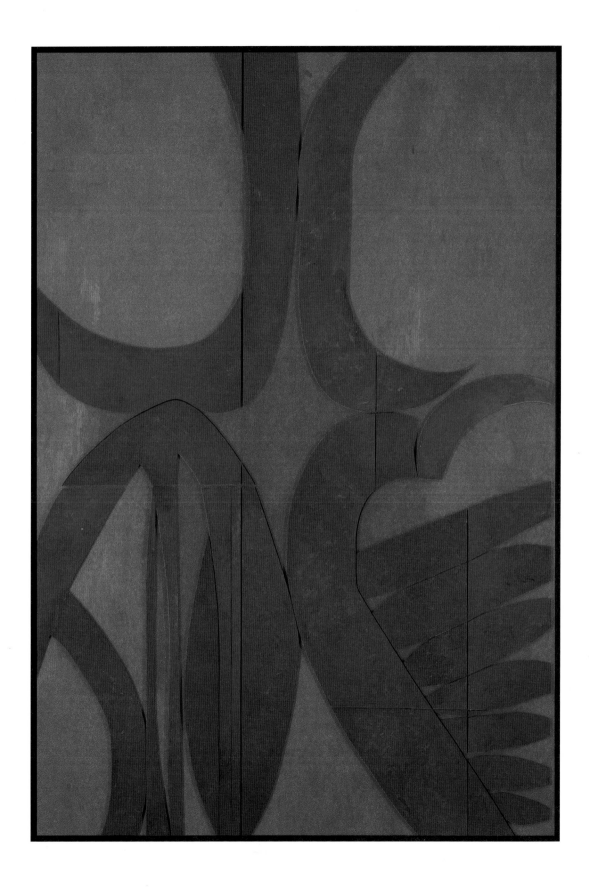

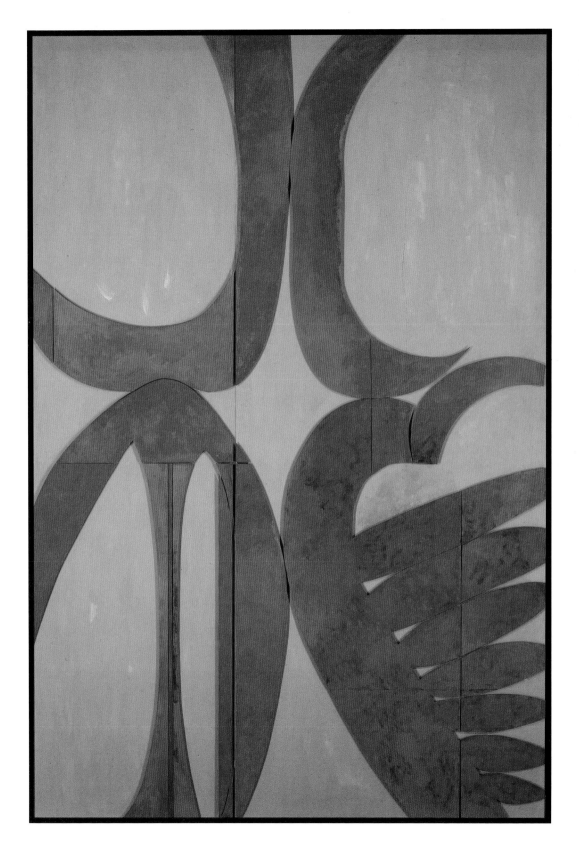

Plate 55. **The Gothic XII,** 1991
Acrylic on aluminum
90¼ × 60¾ inches

Plate 56. **The Gothic XIII,** 1991
Acrylic on aluminum
90¼ × 60¾ inches

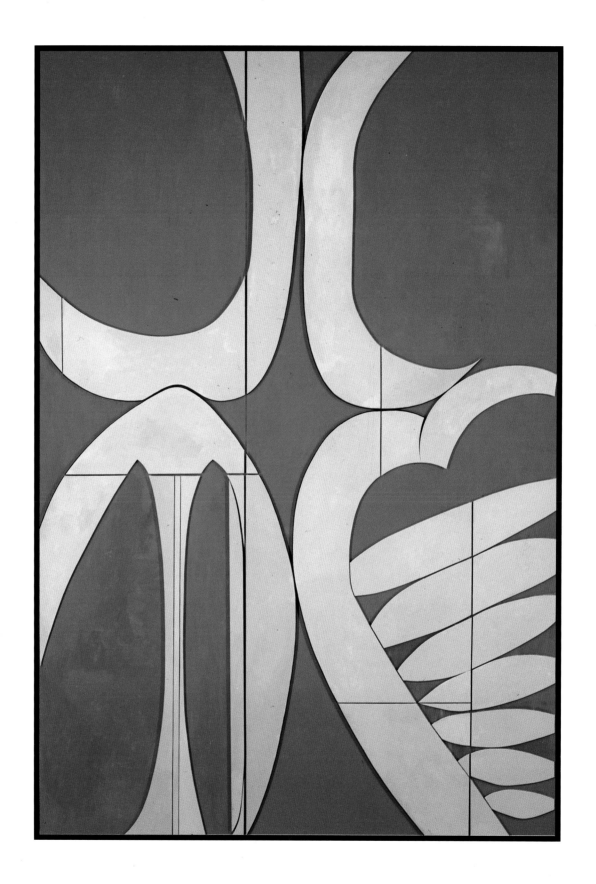

83

Biographical Notes

Born New York City, September 1921.

Education: B.A. in art history, Wellesley College, 1943. Graduate Studies at New School for Social Research, New York (music composition with Henry Cowell, philosophy with Leo Strauss).

1937–43

Studied painting summers and weekends, with various American painters, including Alexander Brook, Maurice Sterne, and Reginald Marsh (at the Art Students' League in New York) and Zoltan Sepeshy (at the Cranbrook Academy of Art in Bloomfield Hills, Michigan).

1943–44

Studied painting with Hans Hofmann during the winter season in New York.

1945–46

Lived and worked in studio on West 12th Street in New York. Worked at Stanley William Hayter's Atelier 17. Included excerpt from Arp's "Notes from a Diary" in announcement of first solo exhibition at the cooperative Jane Street Gallery in New York

> *I do not wish to copy nature. I do not wish to reproduce but to produce...to reproduce is to imitate. Art, however, is reality....*

The art dealer Karl Nierendorf bought a painting from the exhibition (now in the collection of the Solomon R. Guggenheim Museum). Jere Abbot, director of the Smith College Museum of Art, bought a collage, as did Agnes Mongan for the Fogg Art Museum at Harvard University. Elected to membership in American Abstract Artists. Introduced to the dealer Rose Fried by Marcel Duchamp. Came to know Charmion von Wiegand and Burgoyne Diller, and visited Mondrian's studio. In the summer visited Cape Cod for the first time, followed by first solo exhibition in a commercial New York gallery, the Joseph Luyber Gallery in the old Hotel Brevoort in Greenwich Village. The critic Ben Wolf and the dealer J. B. Neumann bought major oils.

1947–48

Married novelist Anton Myrer and left for the West Coast, Rose Fried offered to represent Rothschild's work—beginning a relationship that was to last until Fried's death in the mid-sixties. First studio-home on the West Coast was in Carmel Highlands, a few miles north of the photographer Edward Weston. In 1948 moved to Monterey to the studio-barn built by Jean Varda (the Greek collagist) a few blocks from John Steinbeck's Cannery Row and a short walk from the sea.

Fig. 1. *Abingdon Square*, 1944; oil on canvas, 36 × 27 inches. Photo by Quesada-Burke.

Fig. 2. *Mechanical Personnages (I)*, 1945; oil on canvas, 39 × 27 inches. Photo by Quesada- Burke.

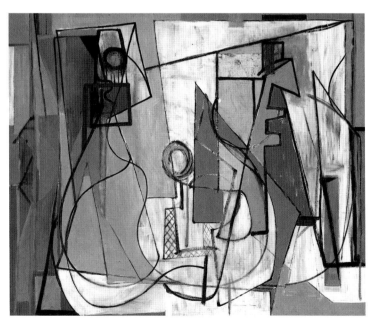

Fig. 3. *Mechanical Personnages (III)*, 1945; oil on canvas, 40 × 48 inches. Photo by Quesada-Burke.

Fig. 4. *Composition*, 1945; collage on cardboard, 5 1/16 × 5 1/2 inches. Photo by John D. Schiff.

1949

Returned east for a visit, summering in Provincetown. Met Weldon Kees, poet and painter, and worked with him on his brainchild, "Forum 49" in Provincetown, which provided a forum for the creative ferment of the time, its subjects ranging from the visual arts to psychiatry to jazz. Renewed contact with Romare Bearden, Robert Motherwell, Milton and Sally Avery, and other New York artists, spending the winter in a loft on the Lower East Side in the same building as Ann and Weldon Kees.

1950

Chose a quotation from the writings of Piet Mondrian (in *Cahiers d'Art*) for an exhibition at the Salon de Mai in Paris:

> *The great simplification of plastic means has been completed. Today the young artist has but to choose.*

1951–57

Once again crossed the country by dilapidated automobile, returning to California in the early spring. Until late 1951 lived in Big Sur, by the edge of the Pacific, reading Herman Melville's *Moby Dick* by kerosene lamp and watching gray whales spout in the ocean below. Twice a week the mail was delivered in a bag hung onto a limb of a roadside tree. No telephones or radios encroached, but there was a fairly good piano available a few miles down the road. Paintings began to reflect experience of Western space and travels in the Southwest. In 1952 withdrew from exhibiting with American Abstract Artists because of increasing concern with "the metaphor of landscape" and changing aesthetic objectives.

1957–58

Left California for a year in France and Italy, stopping in New York for a solo exhibition at the Rose Fried Gallery. The catalogue for this show included a statement by the artist:

> *...The idea is in the mountain: in the mountain rendered eloquently, structured, expanded, which recalls us to our own humanity, our own individual importance —and unimportance—the ultimate power of Poussin's "silent art."*

During that winter worked in Nicolas de Staël's studio in Cap d'Antibes. Made numerous "Merz" Christmas cards for friends in America and inaugurated a tradition of exchanging handmade cards with Sonia Delaunay, a supportive friend.

1959–69

Moved into an old farmhouse in Saugerties, New York, near Woodstock. A previous owner had added to the original structure a studio modeled on Paul Cézanne's in Aix. In first solo museum exhibition, at Albany Institute of History and Art (in 1967), work in oils focused on abstracted landscapes.

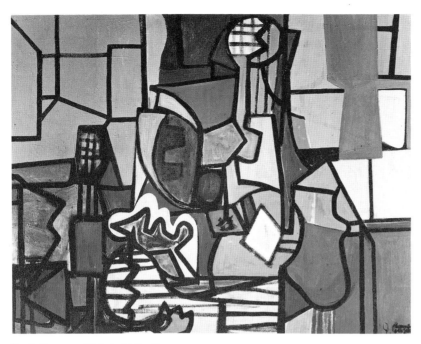

Fig. 5. *Figure and Objects*, 1946; oil on canvas, 38 × 48 inches. Collection of Pennsylvania Academy of the Fine Arts, Philadelphia. Photo by A. Ficalora.

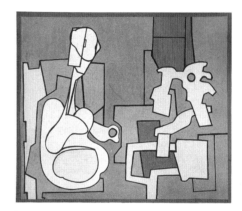

Fig. 6. *The Plague*, 1950 (jacket design for novel by Albert Camus); casein on paper, 14 × 14 inches. Photo by O. E. Nelson.

Fig. 8. *Untitled*, 1950; casein on paper, 14 × 19 inches. Photo by O. E. Nelson.

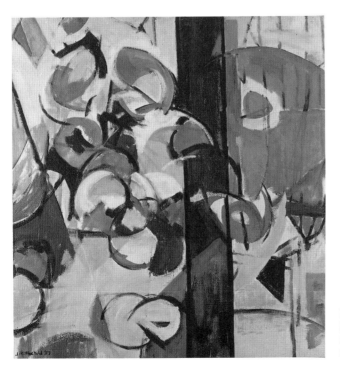

Fig. 7. *Baroque Still Life*, 1957; oil on canvas on board, 40 × 34 inches. Collection of Wellesley College Art Museum, Wellesley, Massachusetts. Photo by John D. Schiff.

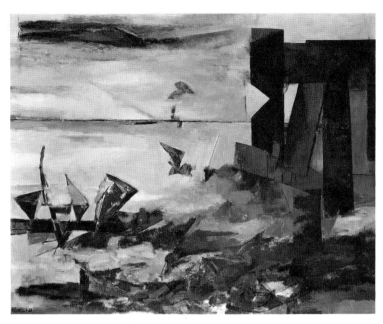

Fig. 9. *Byzantium*, 1955; oil on canvas, 36 × 44
inches. Photo by Paulus Leeser.

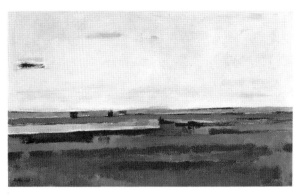

Fig. 10. *Camargue (I)*, 1966; oil on canvas, 18 × 28
inches. Photo by Nathan Rabin.

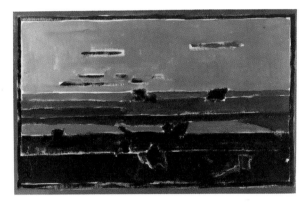

Fig. 11. *Duck Harbor Marsh*, 1966; oil on canvas,
14 × 22 inches.

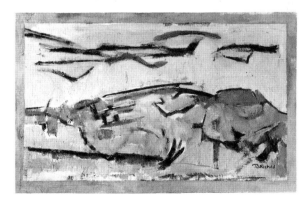

Fig. 12. *Northwest*, 1966; oil on canvas, 18 × 26
inches. Collection of Professor and Mrs. Harry Levin,
Cambridge, Mass. Photo by O. E. Nelson.

1970

Divorced and moved back to New York City, summering on Cape Cod. Appointed artist-in-residence at Syracuse University, teaching advanced drawing and individual studies for graduate students. Executed first reliefs in Syracuse studio.

1971–72

Taught in summer schools at Pratt Institute (New York) and Rhode Island School of Design (Providence). Accepted Annalee Newman's offer of Barnett Newman's studio in the Carnegie Hall building.

1972–80

Served as Corresponding Editor for *Leonardo* magazine. Recommended exhibiting with American Abstract Artists (elected the group's president in 1978). Katherine Kuh visited Rothschild's studio in 1974 and introduced Lee Ault to the artist's new reliefs.

Formed in 1977 (with twelve other artists) Long Point Gallery, a cooperative to show new or experimental work, primarily in Provincetown.

Met Antonina and Krystyna Gmurzynska and began showing at their gallery in Cologne. This led to frequent contact with major works by Russian Constructivists, most significantly Vladimir Tatlin and Liubov Popova.

Long-time interest in Sassanian reliefs and Islamic calligraphy prompted travels in Iran, despite political unrest there; contact with art and landscape exerted a continuing influence on work of following years. Interest in Islamic calligraphy deepened by private viewing provided by Sir John Pope-Hennessy of British Museum Library's great collection of Islamic manuscripts.

1985

Began single-image reliefs: the "Eidolon" series and *Whirligigs*, which were first shown at Rothschild's second exhibition at Gimpel Weitzenhoffer Gallery in 1988.

1988–91

Rothschild's work seen by Soviet Ministry of Culture in Cologne and in Venice through the auspices of Galerie Gmurzynska. When Gorbachev assumed power the Soviet Ministry of Culture proposed a major exhibition of her work at the Tretyakov Gallery in Moscow. Despite the political upheavals surrounding August 19, 1991, the exhibition was held as scheduled.

Solo Exhibitions

* Museum exhibition

*1991 "Beyond the Plane." Tretyakov Gallery, State Museum, Moscow (organized by Galerie Gmurzynska, Cologne; traveled to University of Michigan Museum of Art, Ann Arbor). Catalogue with essay by Richard H. Axsom, curator of exhibition.

1990 "Reliefs." Long Point Gallery, Provincetown, Massachusetts.

*1989 "Eidolons and Whirligigs." Maurice M. Pine Library, Fairlawn, New Jersey.

"Collages." Ingber Gallery, New York.

*1988 "Judith Rothschild: Relief Paintings, 1972–87." Pennsylvania Academy of the Fine Arts, Philadelphia (curated by Linda Bantel). Catalogue with essay by Richard H. Axsom.

*Portland Museum of Art, Portland, Maine (same as above).

"Judith Rothschild Reliefs and Paintings, 1986–87." Gimpel Weitzenhoffer Gallery, New York.

1987 "Selected Paintings." Gimpel Weitzenhoffer Gallery, New York.

1985 "The Shield of Achilles: Relief Paintings and Collages." Iolas-Jackson Gallery, New York.

"Judith Rothschild: Recent Collages and Paintings." Annely Juda Fine Art, London.

Long Point Gallery, Provincetown, Massachusetts.

*1983 "Judith Rothschild: Relief/Collages." Palazzo Grassi, Venice (organized by Galerie Gmurzynska, Cologne). Catalogue with essay by Cynthia Goodman.

*1982 "Rothschild Reliefs." Thorne-Sagendorph Art Gallery, Keene State College, Keene, New Hampshire. Catalogue with statement by M. Ahern, director.

*1981 "Judith Rothschild: Recent Relief Paintings." Wellesley College Museum, Jewett Arts Center, Wellesley College, Wellesley, Massachusetts (recipient of the Wellesley College Alumnae Achievement Award). Catalogue with essay by John Bernard Myers, "A Fine Edge."

"Judith Rothschild: Relief Paintings." Annely Juda Fine Art, London. Catalogue with statement by Sir Roland Penrose.

1980 Long Point Gallery, Provincetown, Massachusetts.

1979 "Sideo's Garden, New Relief/Collages." Landmark Gallery, New York.

*1978 "New Works by Judith Rothschild." Philomathean Society, University of
 Pennsylvania, Philadelphia.

 Lee Ault Gallery, New York.

*1977–78 "Judith Rothschild: Relief/Collages." Neuberger Museum, State University of
 New York at Purchase (curated by Jeffrey Hoffeld). Catalogue with essay by
 B. H. Friedman.

 Lee Ault Gallery, New York.

1976 "Reliefs." Annely Juda Fine Art, London.

 Lee Ault Gallery, New York.

1975 Lee Ault Gallery, New York.

*1972 "Judith Rothschild: Recent Collages." Norton Hall, Buffalo Art Gallery, State
 University of New York at Buffalo.

1971 "Recent Collages." Wellfleet Art Gallery, Wellfleet, Massachusetts.

*1966–67 "Recent Paintings by Judith Rothschild." Albany Institute of History and Art,
 Albany, New York.

 La Boetie Gallery, New York.

 *"Landscapes by Judith Rothschild." Woodstock Art Association, Woodstock,
 New York.

1965 Bragazzi Gallery, Wellfleet, Masschusetts.

1964 Bragazzi Gallery, Wellfleet, Masschusetts.

1962 Bragazzi Gallery, Wellfleet, Masschusetts.

 "Judith Rothschild: Paintings." Knapik Gallery, New York.

1957 "Judith Rothschild: Recent Paintings." Rose Fried Gallery, New York.

1946 "Paintings." Joseph Luyber Gallery, New York.

1945 "Paintings." Jane Street Gallery, New York.

Long Point Gallery artists, summer 1990. Standing (left to right): Carmen Cicero, Budd Hopkins, Sidney Simon, Varujan Boghosian, Rothschild, Anthony Vevers, Paul Resika, Sideo Fromboluti. Seated: Robert Motherwell, Edward Giobbi, Leo Manso, Nora Speyer. Photo by Renate Ponsold.

Selected Group Exhibitions

1991 "Contemporary Artists." Galerie Gmurzynska, Cologne.

"Long Point Artists." Belltable Center for the Arts, Limerick, Ireland.

"Art in the Garden." Cape Museum of Fine Arts, Dennis, Massachusetts.

"25 Women Artists." Woodstock Artists Association, Woodstock, New York (curated by Sam Klein).

"Vision von Raum: Kunst und Architektur von 1910 bis 1990." Galerie Gmurzynska, Cologne.

1990 "Modern Artists." Woodstock Artists Association, Woodstock, New York.

"The Art Show." Feingarten Gallery, Seventh Regiment Armory, New York.

1989 "Contemporary Provincetown." Provincetown Art Association and Museum, Provincetown, Massachusetts (circulated to West Hollywood, California; curated by Ann Lloyd).

"New Acquisitions." Feingarten Gallery, Los Angeles.

"The Assembled Image." Provincetown Art Association and Museum, Provincetown, Massachusetts (curated by Paul Bowen and Jim Forsberg).

"Figuration-Abstraktion." Galerie Gmurzynska, Cologne.

1989–90 "American Abstract Artists." 55 Mercer Street Gallery, New York.

1988–92 "A Living Tradition—Selections from the American Abstract Artists" (circulated by the USIA to museums in Finland, Czechoslovakia, Israel, Yugoslavia, Germany, Poland, Georgia [Russia], and Canada; curated by Phillip Verre).

1988 "Flache-Figur-Raum." Galerie Gmurzynska, Cologne (curated by Werner Kruger).

Feingarten Gallery, Los Angeles.

1986 "50th Anniversary Celebration, American Abstract Artists." Bronx Museum of the Arts, Bronx, New York.

"Cross Currents." Guild Hall Museum, Easthampton, New York; and Provincetown Art Association and Museum, Provincetown, Massachusetts.

Gimpel Weitzenhoffer Gallery, New York.

"New Acquisitions." Portland Museum of Art, Portland, Maine.

1984 "New Acquisitions." Galerie Gmurzynska, Cologne.

"New Acquisitions." Galerie Gmurzynska, FIAC, Grand Palais, Paris.

"10th Anniversary Show." Neuberger Museum, State University of New York at Purchase.

"Survival of the Fittest." Ingber Gallery, New York.

1983–84 "Hans Hofmann as Teacher: Drawings by Hans Hofmann and His Students" (circulated by the American Federation of Arts; curated by Cynthia Goodman).

"Provincetown Printmakers." Provincetown Art Association and Museum, Provincetown, Massachusetts (organized in conjunction with the Smithsonian Institution, Washington, D.C.; curated by Janet Flint).

1982 "Masterpieces of the Moderns." Galerie Gmurzynska, Cologne.

"Twentieth Century Art from the Judith Rothschild Collection." Wellesley College Museum, Jewett Arts Center, Wellesley, Massachusetts.

"Dada-Constructivism—The Janus Face of the Twenties." Annely Juda Fine Art, London.

1981 "About Flowers." Landmark Gallery, New York.

"Tracking the Marvelous." Grey Art Gallery, New York University, New York (curated by John Bernard Myers).

"Klassische Moderne nach 1939." Galerie Gmurzynska, Cologne.

"Autumn '81." Ingber Gallery, New York.

1980 "Long Point Gallery." University of North Carolina at Tulawee (circulated to five midwestern museums).

André Zarre Gallery, New York (three exhibitions during 1980–81 season).

1979 "Hans Hofmann as Teacher." The Metropolitan Museum of Art, New York (curated by Cynthia Goodman).

"Past, Present and Peculiar." Ingber Gallery, New York (circulated for two years to museums in the United States; curated by April Kingsley).

"Mid-Atlantic Regional Exhibition of Collage." University of Delaware at Newark.

"The Language of Abstraction." Marilyn Pearl Gallery and Betty Parsons Gallery, New York (curated by Susan Larsen). Catalogue with preface by Judith Rothschild.

"Fourteen Provincetown Artists of Today." Provincetown Art Association and Museum, Provincetown, Massachusetts (traveled to Slusser Gallery, University of Michigan at Ann Arbor; and University of Chicago).

1978 "5 New York Artists." University Museum, University of Kentucky at Lexington.

"From an American Collection: Recent Acquisitions." Solomon R. Guggenheim Museum, New York.

"3-D/2-D." Pace Gallery, New York (circulated to Centennial Art Gallery, Saint Peter's College, Jersey City, New Jersey).

1977 Long Point Gallery, Provincetown, Massachusetts (permanent roster).

"Selections from the Lawrence H. Bloedel Bequest." Whitney Museum of American Art, New York.

"Women Painters and Poets." Contemporary Arts Gallery, New York University, New York (organized by the Visual Arts Coalition).

"Provincetown Painters 1890s–1970s." Provincetown Art Association and Museum, Provincetown, Massachusetts; and Everson Museum of Art, Syracuse, New York.

1976–78 "Women, Art 1976." Loeb Center, New York University, New York (organized by the Visual Arts Coalition).

"American Abstract Artists—Homage to Albers, Morris and Xceron." Westbeth Gallery, New York.

"Works on Paper from the Ciba-Geigy Collection." Museum of Summit, Summit, New Jersey (circulated to the Wichita Falls Museum and Arts Center, Wichita Falls, Texas; and the Neuberger Museum, State University of New York at Purchase).

1976 "Contemporary Paintings—A Review of the New York Gallery Season, 1974–75." Everson Museum of Art, Syracuse, New York.

"Drawings." Landmark Gallery, New York.

"10 Artists." Landmark Gallery, New York.

1974–75 "Color, Light and Image—Works and Statements." Women's Inter-Art Center, New York (international exhibition curated by Alice Baber).

1974 "American Abstract Artists" (circulated to Weatherspoon Art Gallery, University of North Carolina at Greensboro; and Kresge Art Gallery, Michigan State University at East Lansing).

"Works by Women from the Ciba-Geigy Collection" (circulated to Washington Art Gallery, University of North Carolina at Greensboro; and Kresge Art Gallery, Michigan State University at East Lansing).

1973–74 "Provincetown Art Association Invitational." Provincetown Art Association and Museum, Provincetown, Massachusetts.

"118 Artists." Landmark Gallery, New York.

"Art on Paper." Weatherspoon Art Gallery, University of North Carolina at Greensboro.

1972 "Invitational Drawings Exhibition." Santa Barbara Museum of Art.

"Selected Works from the Kay Hillman Collection." The Baltimore Museum of Art.

"The Non-Objective World, 1939–1955." Annely Juda Fine Art, London (circulated to Galerie Liatowitsch, Basel; and Galleria Milano, Milan).

"The Constructive Line." Centennial Art Gallery, Saint Peter's College, Jersey City, New Jersey.

1970 "The Still Poetic Moon." La Boetie Gallery, New York.

"Panorama of Wellesley Artists." Wellesley College Museum, Wellesley, Massachusetts.

1969 "American, Israeli, and European Paintings." La Boetie Gallery, New York.

1968–72 Wellfleet Art Gallery, Palm Beach, Florida (permanent roster).

1967–72 Wellfleet Art Gallery, Massachusetts (permanent roster).

1967 "32nd Regional Exhibition of Artists of the Upper Hudson." Albany Institute of History and Art, Albany, New York.

"16th Annual Exhibition." The Berkshire Museum, Pittsfield, Massachusetts.

"20 Contemporaries." La Boetie Gallery, New York.

1965 "Small Works." Rose Fried Gallery, New York (final show of the gallery).

Artists in "Forum 49" exhibition, Gallery 200, Provincetown, Massachusetts, summer of 1949.

Front row, left to right: George McNeil, Adolph Gottlieb, Kahlil Gibran, Karl Knaths, Weldon Kees, David Herron, Giglio Dante; middle row, left to right: Lawrence Kupferman, Ruth Cobb, Lillian Ames, Howard Gibbs, Lawrence Campbell, Rothschild, Blanche Lazzell; back row, left to right: Perle Fine, John Grillo, William Fried, Leo Manso, Minna Citron, Peter Busa, Boris Margo, Fritz Bultman, Morris Davidson, Fritz Pfeiffer.

On the wall, left to right: Three paintings by Karl Knaths; one by Fritz Bultman; one by Jackson Pollock; one by Weldon Kees; and one by Rothschild.

1964	"29th Regional Exhibition of Artists of the Upper Hudson." Albany Institute of History and Art, Albany, New York.
	"Christmas Invitational." Cleveland Museum of Art.
1958	"Collage International—From Picasso to the Present." Institute of Contemporary Art, Houston.
1957	"Mid-Season Salon." Camino Gallery, New York.
1956	"International Collage Exhibition." Rose Fried Gallery, New York.
1955	"First Pacific Coast Biennial." Santa Barbara Museum of Art (circulated to California Palace of the Legion of Honor, San Francisco).
1950	"Réalities Nouvelles, 5ᵉᵐᵉ Salon (Salon de Mai)." Palais des Beaux Arts de la Ville de Paris (American Abstract Artists exhibition touring museums in Lucerne, Rome, Milan, and northern European cities).
1949–55	Area Arts Gallery, San Francisco.
1949–52	HCE Gallery, Provincetown, Massachusetts.
1949–50	"New England Painting and Sculpture." Institute of Contemporary Art, Boston (traveled to nine New England museums).
1949	"Forum 49." Gallery 200, Provincetown, Massachusetts.
	"55th Annual." The Denver Art Museum.
1948	"59th Annual Exhibition of Watercolors and Drawings." The Art Institute of Chicago.
1947–54	Perls Gallery, Beverly Hills, California (gallery roster).
1947–48	"58th Annual Exhibition of American Painting and Sculpture—Abstract and Surrealist American Art." The Art Institute of Chicago (American Abstract Artists traveling exhibition touring twenty-three museums in the United States and British Columbia).
1947	Annual invitational exhibition. Pennsylvania Academy of the Fine Arts, Philadelphia.
1946	"Critics' Show." Grand Central Art Gallery, New York (choice of *New York Times* art critic Edward Alden Jewell).

"American Abstract Artists Eleventh Annual Exhibition." Riverside Museum, New York.

"Prize Winners of 1945–46." Addison Gallery of American Art, Andover, Massachusetts.

1945–52 American Abstract Artists annual traveling exhibition (toured in the United States and Canada).

1945 Juried annual exhibition, Institute of Contemporary Art, Boston (second prize).

Selected Museum and Corporate Collections

The Baltimore Museum of Art

CIBA-GEIGY Collection, Elmsford, New York

City Art Gallery, Auckland, New Zealand

The Corcoran Gallery of Art, Washington, D.C.

First National Bank of Chicago, New York and Chicago

Fogg Art Museum, Harvard University, Cambridge, Massachusetts

The Grey Art Gallery, New York University, New York

Israel Museum, Jerusalem

The Metropolitan Museum of Art, New York

Monterey Peninsula Museum of Art, Monterey, California

NCNB Corporation Collection, Charlotte, North Carolina

Neuberger Museum, State University of New York at Purchase

Pennsylvania Academy of the Fine Arts, Philadelphia

Philadelphia Museum of Art

Portland Museum of Art, Portland, Maine

Provincetown Art Association and Museum, Provincetown, Massachusetts

Saint Peter's College, Jersey City, New Jersey

Sammlung Ludwig Museum, Aachen

Santa Barbara Museum of Art

Smith College Museum of Art, Northampton, Massachusetts

Solomon R. Guggenheim Museum, New York

The State Tretyakov Gallery, Moscow

Washington University Gallery of Art, Saint Louis

Weatherspoon Art Gallery, University of North Carolina, Greensboro

The Wellesley College Museum, Jewett Arts Center, Wellesley, Massachusetts

Whitney Museum of American Art, New York

Index